PENGUIN BOOKS

CAN I RECYCLE THIS?

Jennie Romer is one of the leading experts on single-use plastic reduction and recycling in the U.S. She has more than a decade of experience as an attorney and sustainability consultant fighting for effective legislation on waste reduction and single-use plastics, and is routinely sought out by legislators, environmental organizations, and businesses across the U.S. and around the globe. A native of California, Jennie earned her JD from Golden Gate University School of Law and holds bachelor's degrees from UC Santa Barbara. She is a member of the state bars of California and New York. Jennie is a legal associate for the Surfrider Foundation's Plastic Pollution Initiative.

Christie Young is an artist and illustrator currently based in Austin, Texas. She's collaborated with clients of all shapes and sizes, ranging from Penguin Random House to Bumble to Madewell. Her work is a reflection of her interests in nature, travel, and storytelling.

Can I Recycle This?

A GUIDE TO BETTER RECYCLING
AND HOW TO REDUCE SINGLE-USE PLASTICS

JENNIE ROMER

Illustrated by Christie Young

PENGUIN BOOKS

PENGUIN BOOKS
An imprint of Penguin Random House LLC
penguinrandomhouse.com

LIBRARY OF CONGRESS CATALOGING-IN-PUBLICATION DATA
Names: Romer, Jennie, author.
Title: Can I recycle this? : a guide to better recycling and how to reduce
single-use plastics / Jennie Romer; illustrated by Christie Young.
Description: New York, NY: Penguin Books, [2021] | Includes index.
Identifiers: LCCN 2020040573 (print) | LCCN 2020040574 (ebook) |
ISBN 9780143135678 (hardcover) | ISBN 9780143135678 (ebook)
Subjects: LCSH: Recycling (Waste, etc.)—Popular works. | Plastics—Recycling—Popular works.
Classification: LCC TD794.5 .R67 2021 (print) | LCC TD794.5 (ebook) | DDC 363.72/82—dc23
LC record available at https://lccn.loc.gov/2020040573
LC ebook record available at https://lccn.loc.gov/2020040574

Printed in the United States of America
1st Printing

Book design by Daniel Lagin

For Leslie Tamminen

my mentor and friend

Contents

Introduction

How to Use This Book

I'm Jennie Romer, a lawyer, an environmental activist, and a leading expert on single-use plastics. I've spent much of the last decade talking about plastic bag laws, during which I've had the chance to learn an enormous amount about trash and recycling systems. The number one question I get from friends and website inquiries is, "Can I recycle this?"

The answer to this question is not as simple as it may seem. This book will walk you through all kinds of products, teaching you what is and what isn't recyclable, and what happens when something falls in between. There are bright spots to share, like the fact that much of the paper in New York City gets sent on a barge to Staten Island and recycled into pizza boxes. That box plant makes 200,000 pizza boxes a day!

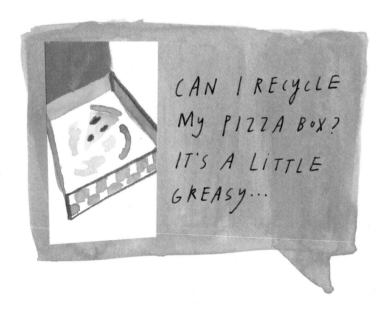

CAN I RECYCLE MY PIZZA BOX? IT'S A LITTLE GREASY...

HEY JENNIE! CAN I RECYCLE THE NETTED BAG MY CLEMENTINES COME IN?

WHAT HAPPENS TO THE PLASTIC BAGS I BRING BACK TO THE GROCERY STORE TO RECYCLE?

JENNIE — CAN I RECYCLE MY PAPER COFFEE CUP??

WHAT ABOUT THIS NUMBER FIVE WITH THE ARROWS ON IT ON MY YOGURT — THAT'S RECYCLABLE RIGHT, IF THERE'S A NUMBER?

The truth is—and you knew this was coming—that recycling alone won't save us or the planet. Recycling is only effective if the materials can be sold for a profit, and the markets for what is profitable fluctuates. Sadly, a lot of our carefully separated and washed plastics end up getting shipped to developing countries to be burned or lost in the environment, harming people's health and contributing to climate change. And that's where policy and activism come in: **The ultimate goal is to adopt sensible and effective policies to reduce single-use plastic and other packaging, and hold producers responsible for making better packaging and paying for the cost of recycling and waste disposal (and cleanup).**

I see this as a little book that can contribute to a big movement. Already these issues are gaining momentum, momentum that we will to continue to build. Because we care. We've been trained to recycle since the 1970s, and so many of us do it faithfully. Plastic bag laws are spreading through our country in spite of tremendous spending and lobbying from the plastics industry. We have also seen the push to ban plastic straws (which are not recyclable!) burgeon into an organized movement by people across the world. Now some cities are starting to adopt policies that require restaurants to serve dine-in orders on real dishes and make utensils available only upon request for takeout and delivery. A world without unwanted plastic utensils cluttering our drawers (and oceans) is coming!

If you're holding this book, you are hungry for accurate information, which I've spent my career gathering. This book will educate, entertain, and get you fired up. We have a lot of work to do. But I know that you're up to the job!

I've teamed up here with the brilliant illustrator Christie Young, the author and illustrator of *Girl Talk: Unsolicited Advice for Modern Ladies* and the hilarious "The Rules Of" series in *GOOD* magazine, which breaks down everyday activities into a series of stylish and humorous rules.

The Structure of This Book

The first section of this book defines what recycling means and introduces terms that we'll use in the rest of the book. You will learn about the numbers inside the chasing arrow symbols on the bottom of your plastic cups, what happens to your recyclables when they reach a sorting facility, and the Rube Goldberg–esque configurations of conveyors, magnets, optical sorters, and sensors that make the sorting happen. We'll also get into how the commodities market relates to recyclables, because all of these fancy sorting methods that boast be-all-and-end-all solutions to environmental problems don't make commercial sense for items that no manufacturer wants to buy.

The second section makes up the bulk of the book and will go through more than sixty individual items to determine whether they're recyclable by explaining what generally happens to each item after it goes into your curbside recycling bin. A few of the references in this section are unique to major cities, including New York City, because delving into specific pilot projects and local anecdotes helps highlight the small variances in recycling depending on where you are. Other examples are more general. For example, we want to make sure that you never recycle batteries curbside— they cause huge explosions at recycling facilities!

You will also learn about the humanitarian issues related to shipping our recyclables overseas and the impacts of plastics on our oceans. After all, the real Take-Homes from this book have less to do with recycling and more to do with how we can change the products that we purchase to make the world a better place by reducing waste and creating a truly effective recycling system. I will discuss personal actions that you can take, suggestions for how

manufacturers can improve packaging, and legislation that mandates these improvements and shifts the responsibility of paying for recycling and waste disposal from local governments back to the manufacturers. I've spent more than a decade as a lawyer fighting for effective plastic pollution laws—now I'm ready to fix the *whole* recycling system.

The Reduce, Reuse, Recycle Mantra

Many of us learned the Reduce, Reuse, Recycle mantra in elementary school, but the main part that most people seem to remember is *Recycle*. The truth is that reduction and reuse are way more important than recycling.

A lot of resources (fuel, water, greenhouse gas emissions) are expended in recycling an item (if recycling is even possible). Choosing to reuse an existing item is better for the environment because the resources have already been expended to make it. And "reduce" means to use less or to not use anything at all.

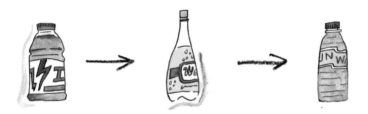

Recycle = material is used to manufacture a new item, retains quality

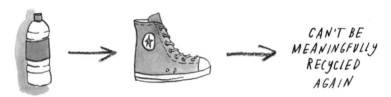

Downcycle = recyclability of a material reduced over time

Upcycle = transformed into a product of greater value than original

REDUCE
USE LESS STUFF

REUSE
USE WHAT YOU HAVE

RECYCLE
& COMPOSTING

TREATMENT
& DISPOSAL

INTRODUCTION to tHE RECYCLING SYSTEM

The U.S. Curbside Recycling System

Let's be very clear: When we talk about recycling in this book, we're talking about the residential curbside recycling system in the U.S., but we aren't talking about just what your city or town lets you put into recycling bins. Just because items are accepted for curbside pickup doesn't mean that they are all ultimately recycled.

 TRASH

 RECYCLING

 COMPOST

Some lucky communities have access to curbside compost bins for yard clippings, and sometimes even food scraps.

Some recycling programs accept more product types than they can process and sell so as to make it easier for customers to figure out what they can recycle. For example, New York City accepts "all rigid plastics" as a strategy to maximize plastics recycling and to collect more valuable materials, knowing that not everything that is collected will have a buyer. On the other hand, the city of Erie, Pennsylvania, instructs residents to recycle only #1 and #2 bottles and jugs, stating that it cannot collect an item for recycling "unless we have an end user who is willing to purchase and recycle that item." Each of these strategies has its own pluses and minuses. There are many variations on the recycling system throughout the U.S., and I'll do my best to point out when and why those variations are likely.

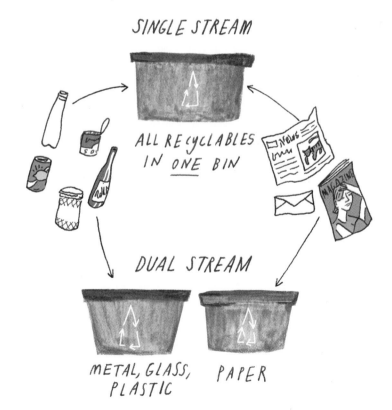

SINGLE STREAM

ALL RECYCLABLES
IN ONE BIN

DUAL STREAM

METAL, GLASS,
PLASTIC

PAPER

Plastic "Recycling" Bags

WARNING: All of your careful sorting of recyclables will go to waste if you put recyclables into a black plastic trash bag—and often your efforts will be for naught even if you put them into a clear plastic recycling bag!

The vast majority of recycling facilities won't open black trash bags because they don't know what will be inside of them, so these bags go straight to a landfill. When I'm in a public place and I see that a recycling can is lined with a black plastic bag, I cringe, because I know that it's probably not being recycled—and often I'll just bring my cans, bottles, and other recyclables home with me.

Most jurisdictions won't accept recyclables in a plastic recycling bag AT ALL! For example, Waste Management (the biggest waste hauler in the U.S.) has a "Recycle Right" campaign that includes a rule that recyclables can never be bagged—even in clear bags. There are a few outlier jurisdictions that allow for clear plastic recycling bags, including New York City, where finding a place to store collection bins is impossible in some neighborhoods. Be sure to check your local recycling program's website to see what your area requires.

Regardless of whether your jurisdiction allows plastic recycling bags, opt instead whenever possible for using recycling cans or toters (that's what recycling insiders call recycling cans with wheels), and skip bags entirely. Also, don't put loose plastic carryout bags in your recycling bin. Plastic film is considered a "tangler"—an item that commonly gets caught in the gears of recycling machinery.

NOpE!

oNLy ALLoWEd iN CERtAin pLACES

UNLiNEd totERS k CANS ARE tHE BESt optioN

What Does "Recyclable" Mean?

"Recyclable" is a valuable term. Companies know that customers feel better about buying products that are marketed as recyclable. Many companies and industry organizations have made attempts to define recycling very broadly—stretching the boundaries of what they can call recyclable—so it's best to rely on the guidance of the Federal Trade Commission (FTC).

The FTC is the federal agency charged with consumer protection. According to the FTC's marketing guidelines, a product or package should not be marketed as recyclable unless at least 60% of customers or communities have access to recycling facilities that accept the item, the item can be sorted by existing recycling infrastructure, *and* the item is then reused or used in manufacturing or assembling another item. Otherwise companies that want to include a recyclable claim on their products must use clear qualifying language (see page 92).

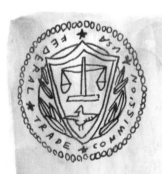

FEDERAL TRADE COMMISSION

Guides for the Use of Environmental Marketing Claims

§ 260.12 Recyclable Claims.

(a) It is deceptive to misrepresent, directly or by implication, that a product or package is recyclable. A product or package should not be marketed as recyclable unless it can be collected, separated, or otherwise recovered from the waste stream through an established recycling program for reuse or use in manufacturing or assembling another item.

(b) Marketers should clearly and prominently qualify recyclable claims to the extent necessary to avoid deception about the availability of recycling programs and collection sites to consumers.

DEFINITION OF "RECYCLABLE":

1. Accessibility: At least 60% consumer access to recycling facilities
2. Sortability: Sorted by existing infrastructure
3. End Markets: Sufficient market demand to convert material into another item

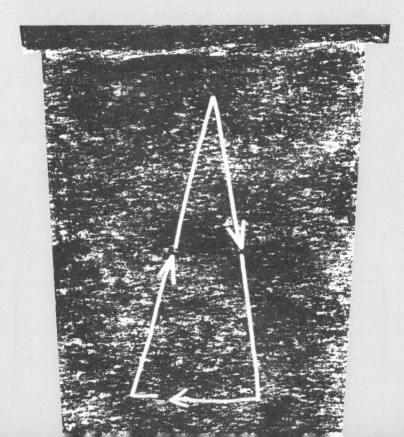

Resin Identification Codes

The Society of the Plastics Industry (now known as Plastics Industry Association) introduced the Resin Identification Code system in 1988. There are seven resin identification codes represented by the numbers 1 through 7. The symbol usually consists of one of these numbers surrounded by chasing arrows in a triangular shape— the Möbius loop, a well-known symbol of recycling—accompanied by an abbreviation of the plastic resin type. Numbers 1 through 6 each represent a certain type of plastic resin, and number 7 (a.k.a. "other") represents a wide category of materials that are not currently recyclable in the U.S.

Many customers assume that the chasing arrows symbol means that a package is automatically recyclable, but the number simply identifies the type of plastic resin used to make the container.

1. PET—polyethylene terephthalate
2. HDPE—high-density polyethylene
3. PVC—polyvinyl chloride
4. LDPE—low-density polyethylene
5. PP—polypropylene
6. PS—polystyrene
7. Other, including materials made with more than one resin from categories 1-6

According to a 2020 report from Greenpeace, *Circular Claims Fall Flat*, only PET #1 and HDPE #2 bottles and jugs meet the FTC's definition of recyclable, but other items, such as plastic clamshells and bags, don't.

THIS REFERENCE WILL COME IN HANDY AS RESINS ARE MENTIONED

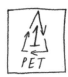 PET

 WATER BOTTLES (NOT LIDS)

 CLEAR PLASTIC CUPS

 *SOME CLEAR CLAMSHELLS

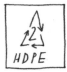 HDPE

 MILK JUGS

 SHAMPOO BOTTLES

 DETERGENT BOTTLES

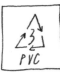 PVC

 VINYL SIDING

 PLUMBING PIPES

 CAR OIL BOTTLES

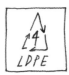 LDPE

 PLASTIC FILM

 SQUEEZE BOTTLES

 FROZEN FOOD BAGS

 PP

 YOGURT CONTAINERS

 RX CONTAINERS

 WATER BOTTLE CAPS

 PS

 PLASTIC UTENSILS

 STRAWS

 PARTY CUPS

 OTHER

 TOYS

 LENSES

 DVDs/CDs

* Some products can be made out of several types of resin. For example, to-go food containers are commonly made out of resins 1, 5, and 6.

History of Resin Identification Codes

Around the time that the Resin Identification Codes (RICs) were created in 1988, public opinion polls showed that an increasing percentage of the general public believed that plastics were harmful to public health and the environment. The plastics industry pushed for recycling—including creating the RICs—which it lobbied to have state legislatures adopt. Facing public skepticism, the plastics industry also launched a $50M-a-year ad campaign to improve plastic's image. Part of the message was "recycling is the answer." Within the plastics industry, however, it was later revealed that even then there was serious doubt that widespread plastic recycling could ever be made economically viable.

From the beginning, there was pushback on the RICs from local recyclers and environmental groups. The problem was (and still is) that the average person saw the symbol and believed the packaging was recyclable, but many of those plastics were not actually being recycled. The Federal Trade Commission later developed guidelines around how and when the symbol could be used. People trust recycling, even if that trust isn't always warranted.

In 1988, Suffolk County, New York, adopted a ban on plastic grocery bags and other plastic food containers—and dozens of similar proposals were pending. The plastics industry sued the jurisdiction, and Suffolk County's law was overturned. Around that time, the plastics industry also began multimillion-dollar advertising campaigns promoting the positives of plastic and highlighting recycling. This tactic was successful in delaying the adoption of local plastic bans for nearly two decades. In 2007, San Francisco, California, was the next U.S. jurisdiction to adopt a plastic bag ban.

"If the public thinks that recycling is working,
then they're not going to be as concerned about
the environment."

—Larry Thomas,
former head of Society of the Plastics Industry

Source: NPR, as seen in *Frontline*'s "Plastic Wars"

Material Types Made with Plastic Resins

So, why do we have so many types of plastic anyway? Plastic resins each have their own unique properties; some are more rigid than others and some withstand heat better than others. We talk mostly about the six plastic resins that have their own codes, but many other plastics are made from blends of various resins and additives. (Blends and additives usually make those plastics impossible to recycle.)

Even within one resin category there can be several resin subcategories (e.g., PETG), as well as several material types (e.g., film, rigid, thermoform, expanded). I know it may sound overly complicated, but you need to consider the resin type and the type of material—as well as additives, including colorants and stabilizers that can sometimes be toxic—when determining whether something is recyclable.

For example, PET can be made into containers for food and beverages, as well as other products, such as film, fabric, and carpeting. There are two types of food and beverage containers made with PET: 1) bottles and jugs, made via a blow molding machine, and 2) thermoform, made by heating a plastic sheet to a pliable temperature and molding to a specific shape.

The main difference is a property called "molecular weight," which decreases whenever the material is processed due to moisture reacting to PET. As a result, material with a higher molecular weight (bottles and jugs) is more valuable, and material with a lower molecular weight (thermoforms) is less valuable. The only way to increase the molecular weight is through a "solid stating process"—but that's cost-prohibitive—so PET thermoforms can't be readily recycled into bottles, but they can be recycled into carpet.

Materials sold on the commodities market each have specifications for exactly what's allowed in bales (solid blocks of sorted recyclables). There isn't currently a reliable market for bales of PET thermoforms, but a certain amount of thermoforms are *tolerated* as contamination in a bale of PET bottles.

PET Bottles bale specification:

Description: Any whole polyethylene terephthalate (PET, #1) bottle with a screw-neck top that contains the ASTM D7611 "#1, PET or PETE" resin identification code and that is clear, transparent green, or transparent light blue. All bottles should be free of contents or free flowing liquids and rinsed.

Product: PET Bottles

Source: Post-Consumer Material

Contamination: Please check with your PET buyer(s) as to their allowance for:

- Other Colored PET Containers
- PET Thermoforms, e.g., microwave trays, dishes, bakery trays, deli containers, clamshell containers, drink cups

Grade A bales only allow a total contamination of 6%.

Source: Institute of Scrap Recycling Industries, Inc.

→ Thermoform isn't desirable, but some is allowed and exact % depends on the agreement between buyer and seller.

PET vs. Polystyrene Food Containers

Plastic products made from different resins can sometimes look nearly identical, but they have different properties. For example, clear plastic clamshells for to-go food are generally made from either PET #1 or PS #6. PET clamshells are made from a PET material designed to be thermoformed, which is slightly different (and less valuable) than the specification of PET used to make bottles. PS, on the other hand, is virtually worthless on the recycling market and usually ends up in landfills or shipped abroad to become someone else's problem.

Keep this in mind if you have a choice of food containers— PET has some chance of being recycled, and PS has virtually no chance of being recycled. But remember: Bringing your own reusable container is the best option!

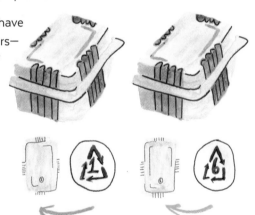

Containers must be cleaned of food to have any chance of being recycled.

CRUMBS

GREASE

SHREDDED LETTuCE

Expanded Polystyrene Food Containers

PS clear food containers and coffee cups are bad, but foam PS is *extra* bad. The clear containers are made from the rigid version of polystyrene, and the foam version is made of expanded polystyrene (a.k.a. EPS). Once it is made, EPS is blown into molds and fused to make products like foam cups and packing peanuts.

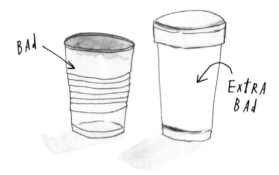

BAd

ExtRA BAd

EPS is made up mostly of air bubbles (up to 95% air), so attempting to recycle EPS adds an extra step where the EPS is densified to remove air. Adding an extra step to the recycling process for something that already has virtually no market value means it's even less likely to be recycled. The light weight of the material also means it's more likley to become windblown litter. Avoid foam cups and containers—even more than other plastics!

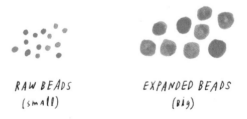

RAW BEADS
(small)

EXPANDED BEADS
(Big)

The Flow of Materials

Recycling is beneficial to the environment for a number of reasons. Most noteworthy here is that recycling allows some goods to avoid the harmful effects of waste disposal and resource extraction. Instead of disposing of a product, the materials are recycled back into raw materials, which are then used to manufacture a new product.

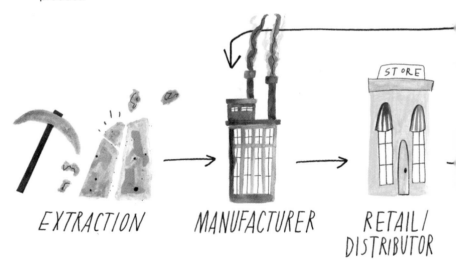

EXTRACTION MANUFACTURER RETAIL / DISTRIBUTOR

Avoiding extraction of new materials by using recycled materials in manufacturing—as well as promoting refill and reuse systems—is important because extraction is often very harmful to the environment. Similarly, skipping waste disposal is also important, because landfill use, incineration, and the leakage of pollution all have very detrimental effects on the environment.

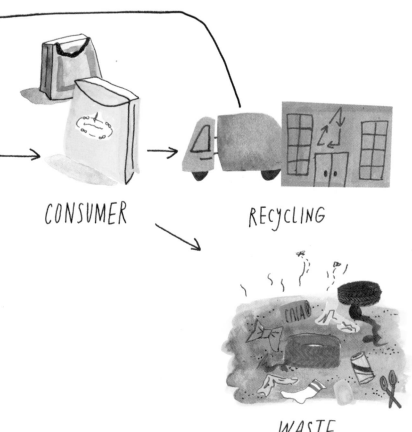

CONSUMER

RECYCLING

WASTE
DISPOSAL

Resource Extraction

Plastic: Most plastic is derived from oil drilling and/or fracking. Ethane cracker facilities turn ethane into ethylene, a building block of most common plastics. Oil- and gas-processing facilities and ethane crackers are associated with major climate and other environmental detriments, as well as lasting impacts on frontline and fenceline communities.

Aluminum: Bauxite ore is used to make aluminum oxide, which is smelted to release pure aluminum. This form of mining produces a significant amount of pollution and is incredibly bad for workers who experience occupational exposures.

Paper: The pulp and paper industry is a big contributor to deforestation—40% of the world's commercially cut timber is used for the production of paper.

Glass: Glass is made from a combination of silica (sand), soda ash, limestone, and cullet (furnace-ready, recycled glass). Glass is relatively inert, and its negative impacts are caused by increased carbon emissions during transportation because glass is heavy.

Fenceline Communities

Frontline communities are communities that are the most vulnerable to climate change and/or are in the midst of heavy pollution. Fenceline communities are communities that are directly affected in some way by a facility's operation (e.g., noise, odor, traffic, and chemical emissions), which could mean neighboring an oil refinery or an ethane cracker plant that makes plastic. Most fenceline communities in the U.S. are made up of low-income individuals and communities of color who experience systemic oppression.

According to a report from the NAACP and the Clean Air Task Force, Black Americans in particular are 75% more likely to live in a fenceline community than the average American. These facilities release a toxic stew of pollutants linked to cancer, brain damage, and birth defects. That same report found that an estimated 138,000 Black children suffer annually from asthma attacks caused by oil and gas pollution. When we consider impacts of extraction and processing on the environment, we must also consider impacts on frontline and fenceline communities.

Source: Fumes Across the Fence-Line: The Health Impacts of Air Pollution from Oil and Gas Facilities on African American Communities

Total Waste Generation

Each year, the U.S. Environmetal Protection Agency publishes a master solid waste generation characterization study, and most states publish their own studies regarding how much of each category is discarded in that state.

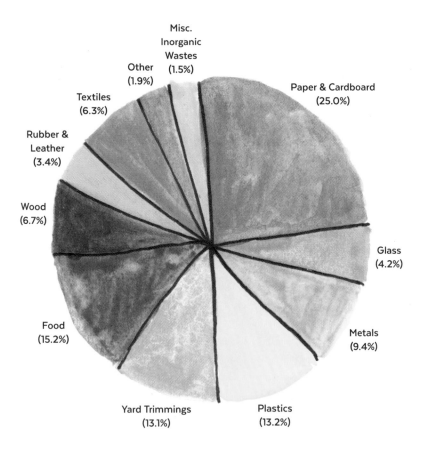

TOTAL = 267.8 million tons

Source: U.S. Environmental Protection Agency

Only 9% of the plastic ever produced
has been recycled.

Source: Geyer et al.

Global Plastic Production

Global plastic production was 311 million metric tons in 2014, the equivalent of more than 900 Empire State Buildings. According to a report by the Ellen MacArthur Foundation, plastic production is expected to double within twenty years and quadruple by 2050.

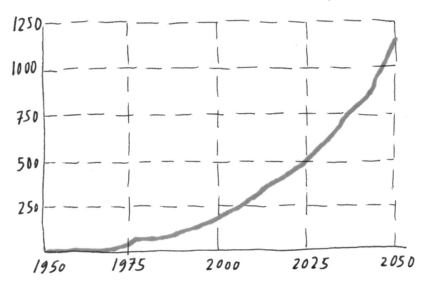

GLOBAL PLASTIC PRODUCTION

(iN MilliON METRIC toNS OVER timE)

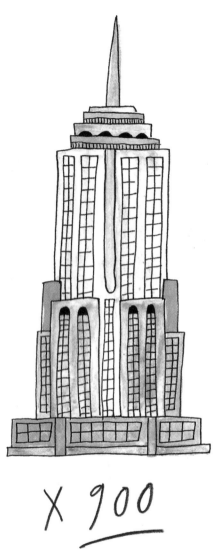

X 900

Global plastic production was 311 million metric tons in 2014, the equivalent of more than 900 Empire State Buildings.

Source: Ellen MacArthur Foundation

What We Recycle

The average single-family household in the U.S. generates 768 pounds of recyclable material per year. This number is based on what Americans currently place in the recycling bin, and we can do better by decreasing overall waste generation and increasing recycling rates.

ESTIMATE OF ANNUAL CURBSIDE RECYCLABLE MATERIAL GENERATION PER SINGLE-FAMILY HOUSEHOLD

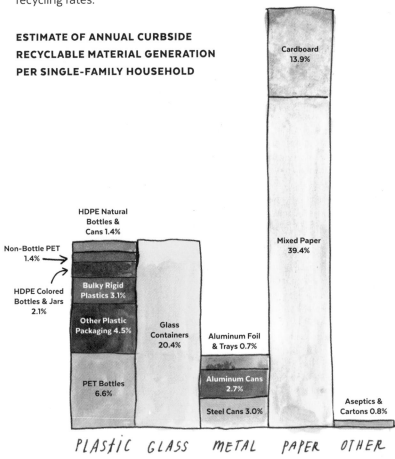

HDPE Natural Bottles & Cans 1.4%

Non-Bottle PET 1.4%

HDPE Colored Bottles & Jars 2.1%

Bulky Rigid Plastics 3.1%

Other Plastic Packaging 4.5%

PET Bottles 6.6%

Glass Containers 20.4%

Aluminum Foil & Trays 0.7%

Aluminum Cans 2.7%

Steel Cans 3.0%

Cardboard 13.9%

Mixed Paper 39.4%

Aseptics & Cartons 0.8%

PLASTIC GLASS METAL PAPER OTHER

Source: The Recycling Partnership

How We Recycle

The majority of U.S. households have access to curbside residential recycling, either automatically provided (53%) or by using a subscription service (6%). About 21% of households have access to recycling only by dropping off their recyclables at local transfer stations; this is especially common in rural and remote areas.

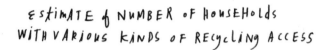

ESTIMATE of NUMBER oF HOUSEHOLds WITH VARIOUS KINDS oF RECYCLING ACCESS

No Recycling
Services Available
6%

Subscription-Based
Curbside (not subscribed)
14%

Access to Drop-Off
Services
21%

Subscription-Based
Curbside (subscribed)
6%

Curbside Recycling
Automatically Provided
53%

Source: The Recycling Partnership

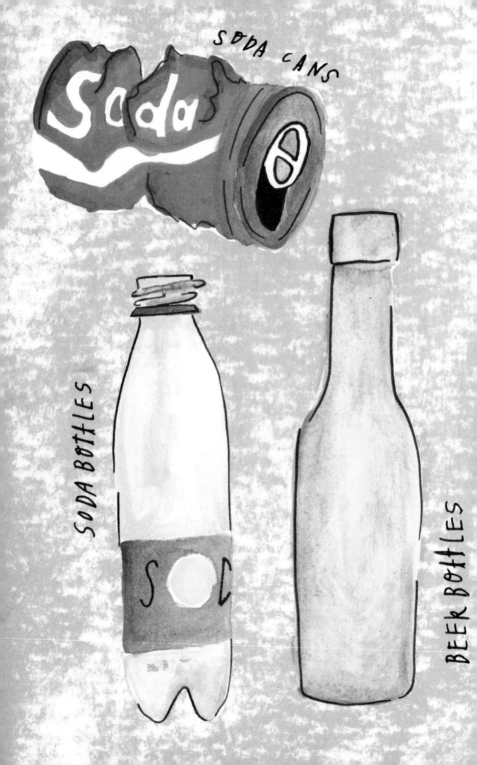

SODA CANS

SODA BOTTLES

BEER BOTTLES

Bottle and Can Deposits

Beverage container deposit laws are in place in ten states, mandating deposit rates that range from five to fifteen cents. States with container deposit laws capture beverage bottles for recycling at a significantly higher rate, and the quality of recycled materials (meaning the level of contamination) is superior to materials collected from curbside recycling programs.

In 1971, Oregon became the first state to adopt a container deposit law, and the primary reason was litter control. By 1979, beverage bottles as roadside litter dropped from 40% of the materials picked up to 6%. Oregon increased the deposit amount to ten cents, and the capture rate for bottles is now an impressive 81%. Capturing material for recycling isn't the same as actually recycling, however, and the material still needs to be sold on the commodities market.

The most sustainable container deposit systems refill and reuse the beverage bottles rather than recycling them. One of the best examples of a refillable beverage container program is in Germany, where 45.7% of all drinks are sold in reusable bottles that are refilled forty to fifty times before they are then recycled. In the U.S., Oregon has the best example, with its BottleDrop Refillables program that uses special glass beer bottles that are returned, sorted, washed, inspected, redistributed to the beverage producers, and refilled.

Note that there is sometimes a bit of tension between recycling facilities that process curbside recycling and calls for expanded beverage container deposits laws. Plastic bottles and aluminum cans are the most valuable recyclables, and deposit laws usually mean that less of those valuable materials will be collected curbside. Legislators developing beverage container deposits should be mindful of this tension and develop container deposit systems that are equitable for recycling facilities.

TRADITIONAL REDEMPTION PROGRAMS

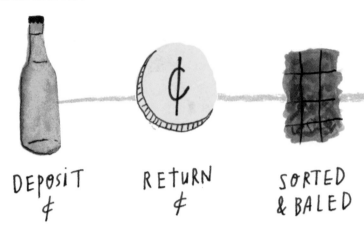

DEPOSIT ¢

RETURN ¢

SORTED & BALED

← THESE ARE THE BEST!

REUSABLE/REFILLABLE PROGRAMS

(LIKE GERMANY & OREGON'S PILOT PROJECT)

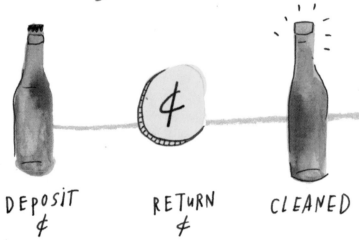

DEPOSIT ¢

RETURN ¢

CLEANED

SOLD ON
COMMODITIES
MARKET

<u>MAYBE</u> BECOMES
RECYCLED CONTENT
IN NEW CONTAINERS

SOLD
AGAIN!
(& AGAIN)

REFILLED

Recycling Drop-Off Centers

Some local recycling drop-off locations are simply collections of dumpsters for trash, cardboard, paper, glass, and plastic. People are responsible for sorting the recyclables themselves into each of the labeled bins. Some transfer stations offer more recycling options and are called recycling centers.

My very favorite local recycling center is the El Cerrito Recycling & Environmental Resource Center. It's a beautiful, spread-out place nuzzled at the bottom of a hillside a couple of miles from Berkeley, California. When I was a kid, I loved sitting in the magazines bin and searching for old copies of *Teen Beat* and *Bop*. More recently, the center got a makeover and now has a circular drive lined with bins for almost anything you would want to recycle, including motor oil, batteries, e-waste, and scrap metal. The center's Exchange Zone also offers specific bins and shelves for donated items to find new homes, like books, office supplies, housewares, hangers, sporting goods, and toys.

The center embodies the culture of reuse, always with at least a few retirees hanging around in the Exchange Zone looking through the recent drop-offs.

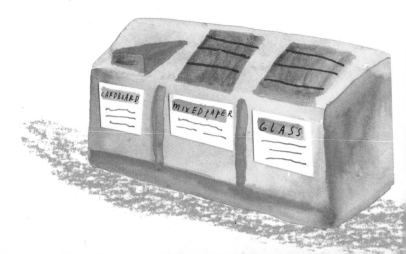

El Cerrito

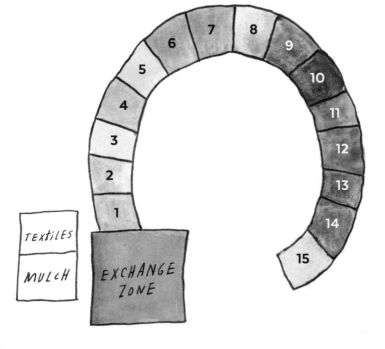

1. EYEGLASSES
2. LIGHTBULBS
3. SYRINGES
4. RX
5. MOTOR OIL
6. BICYCLES
7. E-WASTE
8. BATTERIES
9. WHITE OFFICE PAPER
10. SCRAP METALS
11. OTHER PLASTIC BOTTLES
12. PLASTIC BEVERAGE BOTTLES
13. MIXED PAPER
14. GLASS
15. CARDBOARD

State-of-the-Art Recycling Facilities

Sims Municipal Recycling in New York City, which opened in 2013, is one of the most state-of-the-art facilities in the U.S. This diagram is based on the Sims facility but is meant to illustrate in detail how one particular facility operates.

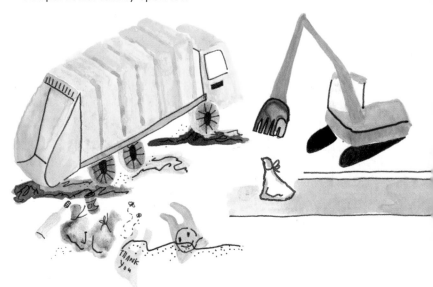

Step 1: Sanitation truck dumps materials onto the **Tipping Floor**.

Plastic carryout bags aren't accepted, but people wishcycle them—don't do that! (See page 62.)

Step 2: An **excavator** (a.k.a. mechanical claw) or front-end loader (a.k.a. tractor) puts material on the conveyor belt headed into the recycling facility.

NYC has a dual-stream recycling system, which means that metal, glass, and plastic are put into a separate bin from paper. Sims processes most of NYC's residential metal, glass, and plastic, and 60% of the material arrives by barge, which reduces truck traffic and emissions. Paper goes to a different facility, much of it via another barge (see page 150). For single-stream facilities, paper would have to be sorted out as well, usually at the beginning of the process.

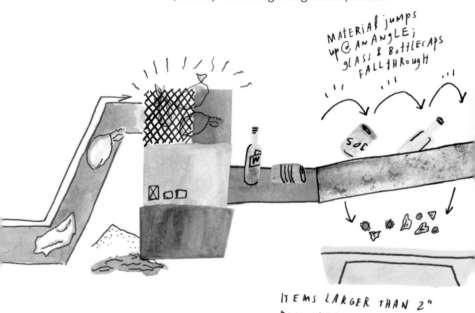

MATERIAL jumps up @ AN ANgLE; GLASS & BoTTLECAPS FALL THRough

ITEMS LARGER THAN 2" PASS OVER THE TOP, SMALLER ITEMS FALL THROUGH (MOSTLy GLASS)

Step 3: The **Liberator** rips open plastic bags to expose what's inside.

Collecting recycling in toters is a best practice, but most recycling in NYC is picked up in clear plastic recycling bags.

Step 4: Disc Screens are rotating discs that crush glass into smaller pieces and allow larger objects to float on top of unevenly rotating discs while "smalls" fall through the discs for collection in bins underneath. Sims sends glass to a separate sorting facility (see page 52).

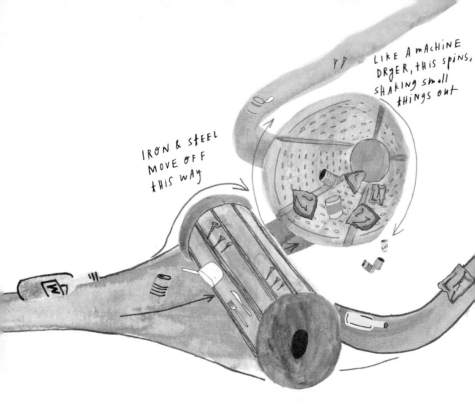

LIKE A MACHINE DRYER, THIS SPINS, SHAKING SMALL THINGS OUT

IRON & STEEL MOVE OFF THIS WAY

Step 5: Drum Magnets attract certain ferromagnetic metals (iron and steel), which are carried to another conveyor belt.

Step 6: The **Trommel** screen is similar to a stretched-out drying machine on tumble-dry. Sims uses the trommel to separate the small metal pieces that fall through the 8" holes in the screen from the large pieces that continue on the conveyor belt.

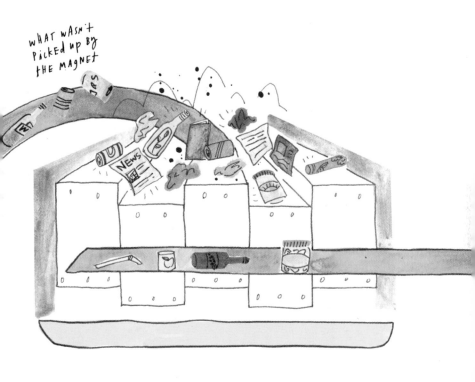

WHAT WASn't
PiCKED UP BY
tHE MAGNEt

Step 7: Ballistic Separators are a series of flat, shifting sieve segments where 2D items like paper and non-rigid plastic (not supposed to be in this recycling stream!) float to the top, while 3D items like bottles and containers roll to the bottom.

Paper isn't supposed to be at this facility, but sometimes people put everything together.

THE INFEED CONVEYOR
BRINGS UNSORTED ITEMS

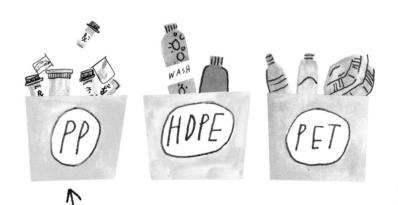

Most facilities optically sort HDPE and PET,
but very few sort PP.

Step 8: The most state-of-the-art recycling facilities use optical sorting to differentiate various types of plastic resins and then shoot them off the conveyor belt and into bins with precise air guns. This is where the valuable plastics are captured, the most valuable of which are usually PET and HDPE bottles and jugs. The plastics that the optical sorters have not been calibrated to capture will stay on the conveyor belt.

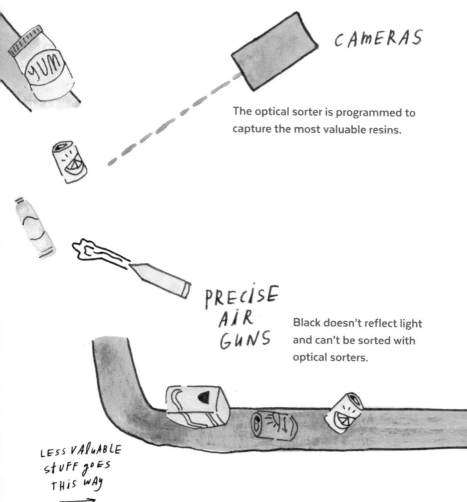

CAMERAS

The optical sorter is programmed to capture the most valuable resins.

PRECISE
AIR
GUNS

Black doesn't reflect light and can't be sorted with optical sorters.

LESS VALUABLE
STUFF GOES
THIS WAY
⟶

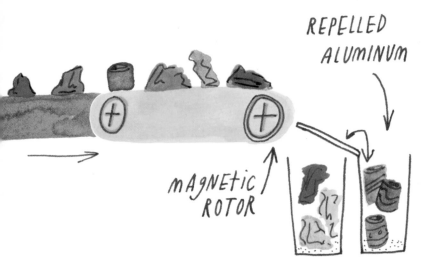

REPELLED ALUMINUM

mAGNETic ROTOR

Step 9: The **Eddy Current Separator** gives a magnetic charge to the non-ferrous metals (e.g., aluminum) before they hit the magnetic rotor so that they are repelled into a bin. Fun with physics! The other material continues down the conveyor belt.

Step 10: **Quality Control:** Workers hand-inspect materials that have been sorted mechanically to ensure the lowest levels of contamination possible and to recover valuables that might have ended up in the wrong stream.

Step 11: After material is sorted by category, that material is put into a **Baler,** which squishes the material into large solid bricks called bales.

Step 12: The **Residue** is all the material that was not sorted and baled. The residue is sent to a landfill, where **Tipping Fees** need to be paid to dispose of the material.

Glass-Recycling Facilities

One big issue with recycled glass in the U.S. is that all the colors are mixed together at most recycling facilities, and the resulting material is of low value. A small portion of glass from recycling facilities, as well as glass collected at drop-off centers, goes to a separate glass processor, called a cullet processor. At the cullet processor, glass is separated from trash and other contaminants (labels, caps, etc.), then sorted by color with an automated optical sorter. Some places in the E.U.—including Berlin, Germany—have a better system for glass recycling, in which consumers sort their glass by color into bins at large buildings and at neighborhood collection centers called Glasigus bins. This makes for a higher-grade glass-recycling stream, which helps explain why European bottlers use more recycled cullet than U.S. bottlers.

It's generally fine if glass bottles are broken before they get to the facility because glass is usually broken as part of the recycling process anyway. However, broken drinking glasses or windows should not be recycled as they are made from a different type of glass, which disrupts the recycling process.

COLORS OF GLASS:

Clear (flint): basic glass elements like sand and limestone

Brown (amber): carbon, nickel, and sulfur added to molten glass

Green: added copper, iron, and chromium

Brown and green glass can be used to protect a container's contents from direct exposure to sunlight to help preserve flavor and freshness.

(glass sorted into color)

CULLET:
RECYCLED BROKEN OR WASTE GLASS USED
IN RECYCLING

The Commodities Market

Bales of paper, plastic, and metal—and bins of cullet—are sold locally, domestically, or internationally. The cost is per ton for most materials, and that cost fluctuates based on supply and demand.

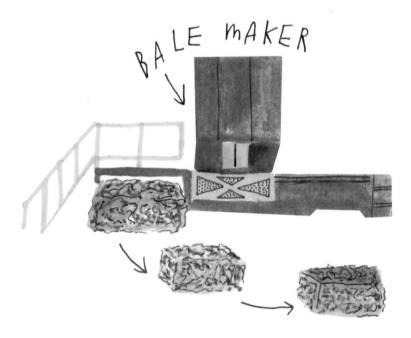

Some small materials like utensils and lids are hard or impossible to bale because they do not have much surface area. These items are difficult to capture, and they would probably fall through the disc screens early in the sorting process.

Bales are sold on the commodities market. Commodities brokers buy and sell recyclables just as they do raw materials or primary agricultural products, such as crude oil and coffee.

Bales are sold on the market if a buyer wants them.

Commodities Pricing:
It's All about End Markets!

The Institute of Scrap Recycling Industries (ISRI) provides specifications for all recyclable materials sold on the commodities market. The price of each bale of material depends on the current price for that specification and the level of contamination present, which is often represented by a letter grade. For example, Grade A PET bottles could be contaminated up to 6% in February 2020 and then valued at $200.60 per ton.

We created the graphs below to illustrate how certain commodities prices have fluctuated over time depending on supply and demand. It only makes economic sense to recycle a material if the material sells for more than it would cost to landfill or incinerate this material. It's all about the end markets!

GLASS

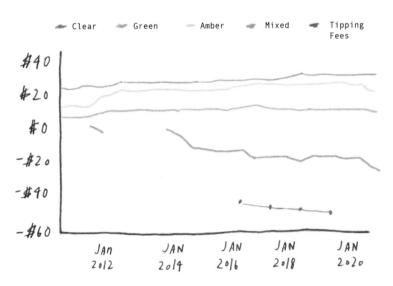

METAL

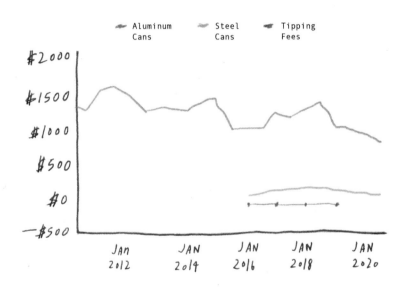

Legend: Aluminum Cans · Steel Cans · Tipping Fees

$2000
$1500
$1000
$500
$0
−$500

JAN 2012 · JAN 2014 · JAN 2016 · JAN 2018 · JAN 2020

PAPER

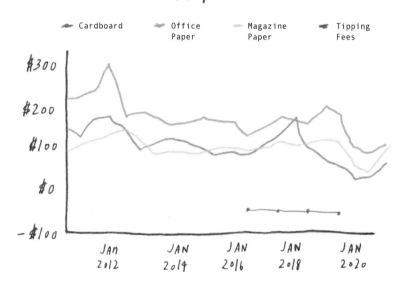

- Cardboard
- Office Paper
- Magazine Paper
- Tipping Fees

$300

$200

$100

$0

-$100

JAN 2012

JAN 2014

JAN 2016

JAN 2018

JAN 2020

PLASTIC

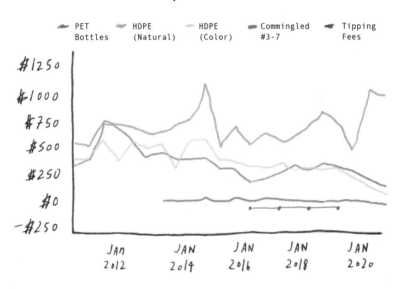

| PET | HDPE | HDPE | Commingled | Tipping |
| Bottles | (Natural) | (Color) | #3-7 | Fees |

$1250
$1000
$750
$500
$250
$0
-$250

JAN 2012 JAN 2014 JAN 2016 JAN 2018 JAN 2020

Source: Historical commodities pricing data printed with special permission from
RecyclingMarkets.net. (Many units are converted from cents/pound to $/ton.)
Tipping fees are courtesy of the Environmental Research & Education Foundation.

Processing Bales of Recycled Material

When bales of recycled material are purchased on the commodities market, that's just the beginning of the process. While we illustrate the process for plastics below, similar steps are used for most other materials.

1. Bale purchased

2. Brought to material recycling facilities

5. Melted

6. Extruded like spaghetti

3. Chopped into pieces

4. Cleaned

7. Cut into small
pieces (plastic ones
are called nurdles)

PLASTIC
NURDLES

20 LBS.

8. Bagged for sale
to manufacturer

Wishcycling Is Not Helpful

All the time and money and energy spent on the collection and sorting and baling of recyclables are for nothing if no one wants to buy the bales of those recyclables. If there is no buyer, the recyclables are essentially garbage and go to either landfills or incinerators. When consumers put non-recyclable items into their recycling bins, those materials take a long and circuitous (and expensive) route to the landfill.

Avoid being part of the problem by not "wishcycling." Wishcycling is when you're pretty sure that something is not recyclable, but you put it in your recycling bin anyway. If you know that an item can't be recycled, don't put it in your recycling bin. Common items that are often wishcycled include:

- tiny pieces of plastic
- plastic film (like carryout bags)
- polystyrene foam
- multilayer packaging (like juice pouches)
- paper napkins

Better yet, whenever possible, avoid buying products that you know aren't recyclable.

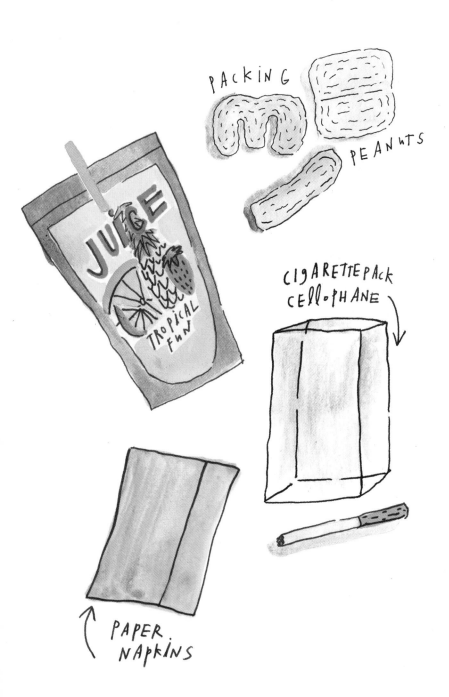

PACKING

PEANUTS

JUICE

TROPICAL FUN

CIGARETTE PACK CELLOPHANE

PAPER NAPKINS

63

Post-Consumer Recycled Content

Mandating post-consumer recycled content is an important way to create end markets for recycled material.

Virgin Content: Produced directly from a feedstock that has never been used or processed before, such as natural gas or crude oil.

Recycled Content: Produced from a feedstock that has already been used or processed.

> Post-Industrial Recycled Content → Recycled material that never left the manufacturing floor (never made it to the consumer).

> Post-Consumer Recycled (PCR) Content → Material that has been reclaimed after it has left the hands of the consumer.

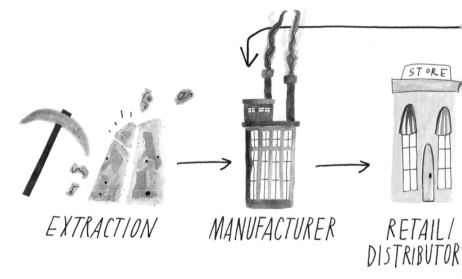

EXTRACTION MANUFACTURER RETAIL/ DISTRIBUTOR

THIS ISN'T AS IMPORTANT,
MANUFACTURERS OFTEN
ALREADY DO THIS

THIS IS WHAT WE NEED TO
CREATE END MARKETS &
MAKE RECYCLING WORK

CONSUMER RECYCLING

Mandating Post-Consumer Recycled Content

Post-consumer recycled (PCR) content is common in items made from certain high-value materials. It is frequently used in aluminum cans because virgin aluminum is expensive, but it is less common in plastics because virgin plastic is relatively inexpensive. Office paper is often available with at least 30% PCR content due to many state laws that require state agencies to only purchase paper with at least 30% PCR content.

Mandating PCR content is essential in order to form a circular economy by creating end markets for recycled material, particularly for recycled plastic. The current cost of virgin plastic nurdles is much cheaper than the cost of recycled plastic nurdles, so it doesn't make economic sense to purchase recycled plastic—and much of our carefully sorted plastic ends up stuck in a landfill, incinerated, or shipped abroad.

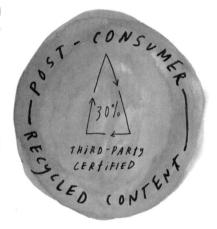

We need to stop this cycle. **The only way to create a reliable end market for plastic, meaning a consistent buyer, is to mandate the use of PCR content for new plastic products.** Many state legislatures have introduced bills that would require a gradual increase of PCR content in beverage bottles starting at 10% and increasing to 50% over the next decade. PCR content requirements are needed for all packaging, but this is a good start, because most plastic beverage bottles are made from recyclable resins.

GREENHOUSE GAS EMISSIONS SAVED BY USING PCR

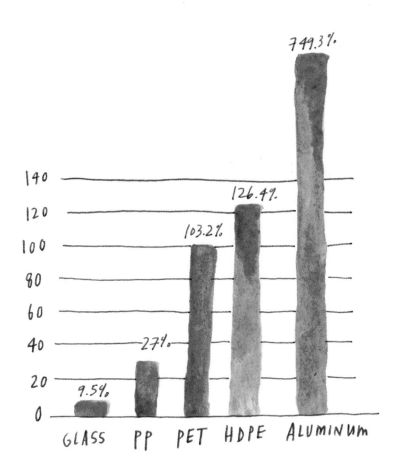

749.3%

140
120
100
80
60
40
20
0

9.5% 27% 103.2% 126.4% 749.3%

GLASS PP PET HDPE ALUMINUM

Mail-In and Drop-Off Recycling Programs for Non-Recyclable Packaging

Some mail-in and drop-off programs for certain products make sense, and some are even mandated as part of Extended Producer Responsibility laws requiring that the producers of certain products pay for their recycling. Hazardous materials, including batteries and computers, should definitely be handled through drop-off and mail-in recycling programs.

However, watch out for mail-in or drop-off recycling programs for typically non-recyclable plastic packaging. These programs are often funded by consumer product brands and are usually just a mechanism for the company to claim their non-recyclable products are recyclable. Oftentimes the customer has to pay for the service. One of these programs allows customers to pay $84 for the opportunity to recycle a small box of typically non-recyclable items—including rigid #6 PS plastic cups, chip bags, and multilayer baby food pouches. These products cannot be effectively recycled on a large scale, but these companies have a theory that if you have enough of anything, you can figure out a way to recycle it. Skeptical? I am too.

What happens to all these items once they are collected? Most of the time it's not totally clear. If anything, these items are likely downcycled—meaning that they are turned into something that can't be recycled again, like a wallet made from a candy bar wrapper or a bench made from party cups. Shipping a #6 PS party cup across the county to *maybe* make a bench isn't resourceful or sustainable—imagine all the greenhouse gases emitted during the

transport of individual materials. If the company really wants to make benches out of PS, companies could simply buy bales of PS on the commodities market for next to nothing (much of it currently goes to landfills). These services are only in place to make customers feel better, or to justify a company's claim that their products are being recycled. Instead, do your best to avoid non-recyclable plastics.

OTHER WASTE PROCESSING & DISPOSAL

Curbside Composting

Some cities offer curbside compost programs for yard waste and food scraps. Since food makes up a significant percentage of what we throw away—around 14.9% in 2017—converting food scraps into soil can avert significant landfill methane emissions in the process.

The U.S. Environmental Protection Agency specifies that compost should be maintained at minimum operating conditions of 40°C (104°F) for five days, with temperatures exceeding 55°C (131°F) for at least four hours of this period (that's hot!)—and some states mandate additional requirements. Windrows (long lines of material heaped up by the wind or by a machine) are turned regularly to ensure that all the composting material spends some time in the center of the pile where bacterial activity produces heat that encourages further breakdown.

Like landfills, large composting facilities are difficult to site—meaning find an appropriate location for—because decomposing food can be rather smelly (yes, that's putting it lightly!). Microhaulers and microsites are also being piloted within cities; for example, BK ROT in Brooklyn, New York, collects food scraps by bicycle, and compost is created using compost bins and small windrows at a community garden plot. Such systems create green jobs, reduce emissions from transport, can be easier to site since they're small and spread out, and result in new fertile soil that can be used locally.

Surprising things that are compostable in municipal programs (depending on the program):

- Greasy pizza boxes
- Paper coffee filters
- Wooden toothpicks
- Hair and nail clippings
- Wine corks (not plastics or coated)

And not compostable:

- "Biodegradable" plastic forks (see page 77)
- Coated paper
- Pet waste (not in most programs!)

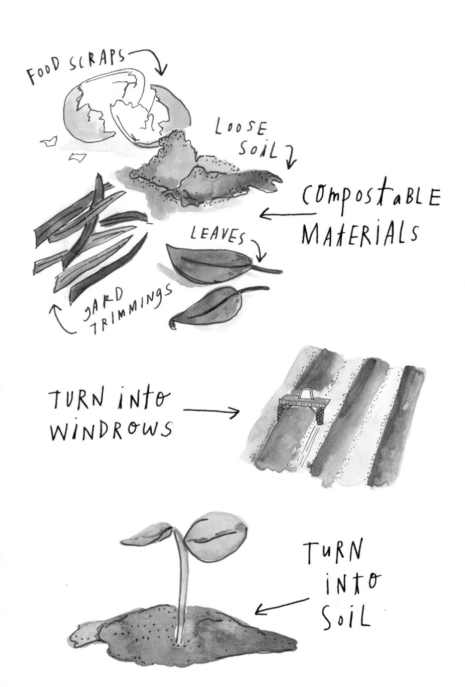

FOOD SCRAPS

LOOSE SOIL

COMPOSTABLE MATERIALS

LEAVES

YARD TRIMMINGS

TURN INTO WINDROWS

TURN INTO SOIL

Anaerobic Digestion

Anaerobic digestion is an alternative to composting for food scraps. Composting refers to the decomposition of organic matter when oxygen is present. "Anaerobic" means no oxygen—anaerobic digestion is the decomposition of organic matter without oxygen.

The process of anaerobic digestion takes food waste and blends it, like a garbage disposal on an industrial scale, to create a consistent bioslurry (the facilities call it a "milkshake"), which is fed into a small digester or a wastewater treatment plant. Digesters act like stomachs to break down material. Anaerobic digestion systems can come in many sizes and have the advantage of being a more closed system that does not need a lot of space and is less smelly than windrows. Also, some of the most advanced wastewater treatment plants can collect the biogas produced and feed it into existing gas pipelines as a substitute for natural gas derived from fossil fuels. Disadvantages include the difficulties associated with making a very consistent slurry, and fertilizer pellets that result from wastewater treatment plants are sometimes hard to dispose of.

Step 1: Residential and commercial food scraps are delivered to the tipping floor.

Step 2: Specialized tractors pick up food scraps, and rotating cogs at the bottom of the tractor bucket shred food (and packaging) over a bin.

Step 3: A metal vise cranks the food to one side and squishes the liquids out.

Step 4: Plastic and other contaminants float to the top and are pushed to a waste bin.

Step 5: Food goes into a mixing tank where liquid is added and mixed, and the slurry produced is called a bioslurry.

Step 6: In NYC, the bioslurry is driven to the Newtown Creek Wastewater Treatment Plant and put in "digester eggs" along with sewage, which converts the slurry to biogas (our stomachs do the same thing!).

This is an example of the Waste Management anaerobic digestion facility, which feeds into the Newtown Creek Wastewater Treatment Plant in New York City.

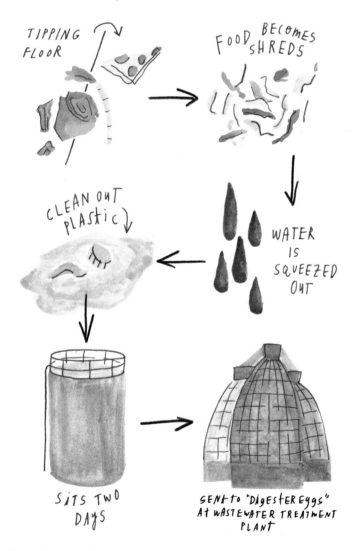

TIPPING FLOOR

FOOD BECOMES SHREDS

WATER IS SQUEEZED OUT

CLEAN OUT PLASTIC

SITS TWO DAYS

SENT TO "DIGESTER EGGS" AT WASTEWATER TREATMENT PLANT

Someday soon, the Newtown Creek Plant plans to capture the biogas generated into the National Grid system.

"Compostable" Plastic

The Federal Trade Commission recognizes that some customers seek out (and often pay more for) plastics that are advertised as compostable. The FTC's guidelines require that a marketer claiming that a product is compostable should have competent and reliable scientific evidence that the product will break down into usable compost. Several states, including California and Washington, take the guidelines a step further and require that plastic products marketed as compostable must obtain a certain certification, verifying that the product will degrade under certain conditions at a compost facility.

Unfortunately, even certified compostable plastic products aren't always accepted at commercial composting facilities. Oregon composters released a statement explaining that they don't want packaging and serviceware: Not all certified compostable plastic items actually break down fully or quickly. Using compostable plastic often increases costs and makes composters' jobs harder, because these materials contain chemicals that transfer into finished compost, and it hurts resale quality. Long story short: Compostable plastic has issues.

I DON't REALLy BREAK DOWN
ALL tHE wAy / ALl THAT FAst

Biodegradable plastics are much more of a buzzkill. There are no approved certifications for plastic products marketed as biodegradable, and some states even ban the use of the term "biodegradable" to describe plastic unless certain proof is shown (and thus far that hasn't happened).

THE TAKE-HOME

Compostable plastic isn't quite what it's cracked up to be, and biodegradable plastic is even less regulated—it usually just contains regular plastic with an unproven additive. Personally, the idea of composting plastic doesn't sit well with me, because we don't know what proprietary chemicals are in these products. I don't want them in my soil.

COMPOSTABLE TAKEOUT CONTAINERS & PFAS

Similar to compostable plastic, some fiber-based and paper takeout food containers marketed as compostable also have issues breaking down in commercial facilities.

Another big concern with these containers is that manufacturers sometimes use fluorinated chemicals (a.k.a. per- and polyfluoroalkyl substances, or PFAS) to make them water- and grease-resistant. PFAS are a chemical class including thousands of chemicals linked to a range of health concerns, including hormone disruption, cancer, and reproductive toxicity—and can also be found in packaging that's not compostable, including fast-food wrappers. Several local and state laws addressing foodware now often include PFAS bans, which will help.

Incineration

Incinerators are facilities that treat waste by burning it. The process of incineration uses special furnaces heated to 1800–2200°F, burning about 75% of the material and leaving about 25% as residual ash that still requires landfilling or disposal. Most of the waste burned is municipal solid waste, but hazardous and medical waste is also burned.

The main problem for incinerators is air pollution. In newer incinerators, air pollution control devices, such as air filters and "scrubbing" devices, capture and concentrate some of the pollutants, but they don't eliminate them. Incinerator dust is toxic and blows onto nearby communities. Harmful pollutants—including dioxins, furans, heavy metals, and particulate matter—inevitably escape and create emissions in the atmosphere.

Incinerators are a major environmental justice issue. In fact, disproportionate placement of incinerators and other waste facilities in communities of color and low-income communities was a key driver for the emergence of the environmental justice movement. In 1985, there were nearly 200 incinerators in operation in the U.S., but by 2018, only 76 plants remained. A 2019 study by the Tishman Environment and Design Center found that 79% of incineration facilities were located in low-income communities and communities of color. When air pollutants are restricted to these areas, the result is a disproportionate health crisis that causes respiratory damage, reproductive issues, and increased rates of cancer for those in these communities.

In recent years, incinerators have been rebranded as waste-to-energy (WTE) facilities. As of 2018, most of the incinerators in the U.S. were located in states that classify municipal solid waste

incineration as a renewable source of energy. Also, some "Zero Waste to landfill" plans allow waste to go to WTE facilities. Incineration should not count as renewable energy or Zero Waste! Quite the opposite: Incineration means that we have to extract more virgin materials from the earth to replace the incinerated material, which takes tremendous amounts of energy compared with reusing or recycling what we already have.

The average tipping fee (the amount cities and counties pay to dispose of trash) in the U.S. is generally higher in states with incineration. In 2019, states with incineration paid an average tipping fee of $59.93 per ton, and states without incineration paid an average of $53.58 per ton.

Pink or purple smoke means that iodine is being burned, likely from medical waste.

Chemical Recycling

What we've talked about thus far falls within traditional mechanical recycling, where plastic is mechanically crushed and remelted into granulate to make new products, and the molecular structure is preserved. Now let's talk about what the plastics industry calls chemical recycling, or sometimes advanced recycling, which splits plastic to a molecular level. There are two distinct types:

1. PLASTIC-TO-PLASTIC REPOLYMERIZATION

Plastic-to-plastic repolymerization is when plastic is reduced to the polymer or monomer level, then rebuilt into a new plastic product. This technology is mostly still in the small pilot project phase, has unproven sustainability claims, and is very expensive. That being noted, if significant advances are made, there *may* be a place for repolymerization for items that can't be mechanically recycled.

Polymer: a molecular structure consisting of a large number of similar units bonded together

2. BULK CHEMICAL RECYCLING (A.K.A. PYROLYSIS)

Bulk chemical recycling is a method to be most wary of—it's pyrolysis, with a fancier-sounding name. Pyrolysis is a common technique used to melt plastic waste into liquid or gaseous fuels in an oxygen-deprived environment so that there is no combustion (a.k.a. burning). Fuel created by pyrolysis is most commonly used as an additive to marine diesel fuel (one of the least regulated fuels). Essentially, chip bags are turned into ship fuel, and the chemicals from the chip bag are released into the air when the fuel is burned.

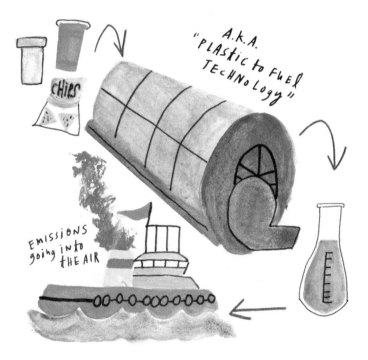

This isn't recycling. At best, it's downcycling; at worst, a roundabout way to burn plastic. Perhaps the plastics industry understands that many people associate chemistry with something clean and impressively scientific—maybe that explains their push to call this chemical recycling?

Modern Sanitary Landfills

Landfills for municipal solid waste are regulated under Subtitle D of the Resource Conservation and Recovery Act, which was enacted in 1988. The act requires landfill permit holders to meet certain restrictions, including location, a redundant liner system, operation and design criteria, groundwater monitoring, and closure criteria. For example, collection of leachate (a.k.a. garbage juice) is highly regulated because leachate can contaminate groundwater. Landfill owners and operators must also ensure that the concentration of methane gas—a potent greenhouse gas released by decomposing trash that contributes to climate change—does not exceed certain limits. The methane collected is either burned off or, in some modern landfills, can be cleaned and converted into biogas (like natural gas).

Landfills are a classic NIMBY (not-in-my-backyard) issue, so finding locations for new landfills is very difficult. Subtitle D includes extensive regulations that make landfills safer, but issues are bound to arise at even the most state-of-the-art landfills. There are other downsides for the adjacent communities, including truck traffic hauling waste to the landfill, very bad smells, and materials (including plastic bags) becoming windblown litter.

Landfills are sealed, oxygen-free environments that are not designed to break down trash (pretty much just store it in a tomb). However, organic material in landfills slowly decomposes and typically produces methane gas for fifteen to thirty years after the landfill closes. According to the Federal Trade Commission's Green Guides, it is deceptive to market a product as biodegradable if the item does not completely decompose within one year after

customary disposal, so items that are customarily disposed of in landfills cannot be marketed as "biodegradable in landfills."

Cities and counties pay tipping fees to send our trash to landfills. The average landfill tipping fee in the U.S. in 2019 was $53.58 per ton.

MODERN SANITARY LANDFILL

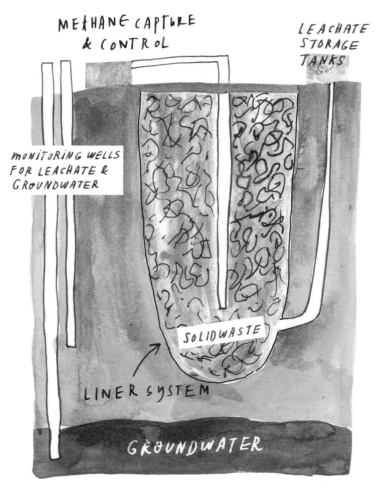

METHANE CAPTURE & CONTROL

LEACHATE STORAGE TANKS

MONITORING WELLS FOR LEACHATE & GROUNDWATER

SOLID WASTE

LINER SYSTEM

GROUNDWATER

Zero Waste and Alternative Daily Cover (ADC)

ASH & CEMENT KILN DUST

TREATED AUTO SHREDDER WASTE

CONSTRUCTION WASTE

COMPOST

CONTAMINATED SEDIMENT

SLUDGE

SHREDDED TIRES

YARD TRIMMINGS

POWDERED GLASS

Zero Waste is the policy goal of diverting all waste from landfills and incineration, and in recent years has been embraced as a lifestyle and design framework. Many cities and states have adopted Zero Waste goals, often including benchmark diversion rates by certain years. San Francisco, California, has notoriety for having the highest diversion rate: 80%. Other cities claim that San Francisco got there by calculating its total waste differently; for example, by counting diversion of heavy construction materials rather than just post-consumer commodities. Regardless, San Francisco is a Zero Waste leader.

$$DIVERSION\ RATE = \left(\frac{WEIGHT\ OF\ WASTE\ DIVERTED\ FROM\ LANDFILL}{WEIGHT\ OF\ ALL\ WASTE} \right) \times 100$$

Federal regulations mandate that landfill operators cover landfills every night to control pests, fires, odors, blowing litter, and scavenging. Cover can either be six inches of soil or alternative daily cover (ADC) made up of a number of materials. The allowance for ADC is good because it cuts down on the need to excavate and haul soil. Whether ADC is considered "diversion" from landfill is controversial, and definitions vary. A significant amount of recycled glass is sold as ADC rather than to be made into new glass, which is not the highest and best use of the material but beats being disposed of in a landfill as trash. That's something to keep in mind when we review glass recycling!

INDIVIDUAL ITEMS:

CAN I
RECYCLE
THIS?

Colors Used in This Section

The pages in this section include a color bar that distinguishes levels of recyclability. The colors and labels used in this section reflect what happens to each item in the recycling process. These indicators are meant to help you make better decisions when buying products that are recyclable and to explain the need for legislation to address problematic products.

This section relies on the Federal Trade Commission's definition of "Recyclable" as discussed on page 16.

What qualifies as recyclable is not completely static. If PCR content mandates are adopted for plastic packaging, then manufacturers will be motivated to buy more recycled materials, and end markets would likely improve. If broader policies are adopted that require producers of packaging to pay for the recycling and disposal of their products, as well as better product design, that will take the financial pressure off municipal recycling facilities currently flooded with unrecyclable materials. All of this means that the definition of what products are recyclable could expand over time, but only if we start working on these policies now!

LEAST RECYCLABLE

Not Recyclable

Not Totally Recyclable,
only the paper layer

What you should put in your recycling bin is often a very different matter. I encourage you to follow the guidance provided by your curbside recycling program, particularly if your program assesses fines for non-compliance. For example, I don't want you to not recycle a PS #6 cup if your jurisdiction accepts all rigid plastic—you might end up with a ticket! However, I want you to understand that your cup is very unlikely to end up being recycled into another cup.

To find out what materials your local community's curbside recycling program accepts, first try looking online at your city recycling department's website, which is sometimes called the Department (or Bureau) of Sanitation. The website will usually include a list of what's accepted and what's not. Sometimes there is also a FAQ section and a phone number to call with additional questions. If you're lucky, your local recycling facility might even offer facility tours!

We will also note whether something is compostable or has special drop-off recycling programs available, but the color will focus on curbside recyclability only.

MOST RECYCLABLE

Recyclable, but have issues

Recyclable

PLASTIC CARRYOUT BAGS
NOT RECYCLABLE

Almost all curbside recycling programs in the U.S. don't accept plastic bags, even though people really want to recycle them (or just get rid of them). The bags end up clogging the recycling machinery. While some grocery stores offer to take them back, there isn't much transparency about what happens to those plastic bags. But if you're remembering to take your bags back in to recycle, why not bring your own bag to the store to begin with?

1. You go grocery shopping and forget a reusable bag. (You usually remember, you swear!)

2. You walk home. (Fun fact: Plastic grocery bags are used for an average of only twelve minutes.)

3. You consider your options: the recycling bin, the trash can, and the spot under the sink.

4. You toss the bag in your recycling bin. (The city's signage says no plastic bags, but maybe it'll work this time?)

5. At the recycling facility, workers then have to pull the plastic bags out of the sorting line—by hand.

6. Plastic bags get caught in the gears and clog the machines. Often the entire operation needs to be shut down so that workers can remove plastic films.

7. Plastic bags and other films that are picked out usually go to landfills.

8. The Take-Home: Bring *your own* bag and keep plastic bags out of your recycling bin.

1.

2.
THANK YOU

3.

4. you toss the bag in the recycling bin; city signage says NO BAGS, BUT MAYBE IT'll WORK THIS time?

↑ DON'T DO THIS! IT'S CALLED "ASPIRATIONAL RECYCLING," OR WISHCYCLING

5.
HANK YOU

6.

7.

8.
W N Y C
W N Y C
W N Y C

PLASTIC CARRYOUT BAGS
(IN GROCERY STORE DROP-OFF BINS)
NOT RECYCLABLE

Almost no curbside recycling programs in the U.S. accept plastic bags. If you want to recycle plastic bags, your only option is to drop them off at grocery stores with plastic bag recycling programs.* You might have noticed that language next to the chasing arrow symbol on your plastic bags; it's called a qualified claim—explaining that the bag isn't recyclable curbside.

There is a market for some clean plastic films. The difference between using store drop-off programs for plastic bags and recycling them in your curbside bin is that drop-off material is a much cleaner stream—meaning that it's not contaminated with other materials. Drop-off programs also mean that the bags don't go through the recycling facility and get stuck in the gears of machinery.

Laws requiring that certain plastic bags be made from post-consumer recycled (PCR) film are the best way to ensure that plastic bags and other films recycled through drop-off programs are recycled back into new bags and films. Under PCR content laws, manufacturers have to purchase recycled plastic pellets (called nurdles) to make plastic bags, which makes that material

* Some programs accept other films, including cereal box liners, produce bags, and dry-cleaning bags. Bonus tip: I suggest generally trying to avoid dry-cleaning bags, but if you get them, you can tie a knot at the top of the bag and reuse it as a big trash can liner (or for storage).

more valuable. For example, California law requires that trash bags have 10% PCR content and that reusable bags made from film have 40% PCR content. These laws are rare, though, and the majority of recycled plastic bags either go to make composite lumber material or go to the export market, and are not made into new plastic films.

PLEASE RETURN THIS BAG TO A PARTICIPATING STORE FOR RECYCLING

QUALIFIED RECYCLING CLAIM

PAPER CARRYOUT BAGS
RECYCLABLE

Standard brown kraft paper bags have long fibers, which are very desirable for recycling. Longer fibers mean there's more surface area to cling to the screens used in the paper-recycling process. Only a small amount of the bonding ability and strength is lost when these fibers are recycled, meaning that some fibers can be recycled many times.

What if the paper sack your burrito came in has grease on it? Tear off any grease-stained bits from the bag and recycle the clean parts.

What about bags with ribbon or rope handles? It's best if you rip off and trash any handles that aren't made from paper. If you don't, they will end up being skimmed out before the pulping process, so don't worry too much.

Side note: To save trees and reduce greenhouse gas emissions, many carryout bag laws require that paper bags include some post-consumer recycled content—usually 40%!

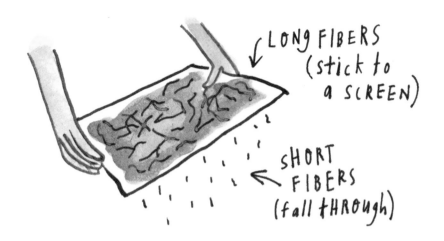

LONG FIBERS
(stick to
a SCREEN)

SHORT
FIBERS
(fall tHROugh)

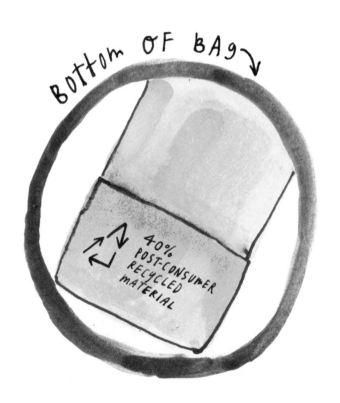

BOTTOM OF BAG

40%
POST-CONSUMER
RECYCLED
MATERIAL

CARDBOARD BOXES
RECYCLABLE

Cardboard is recyclable and often very valuable on the recycling commodities market. Make sure to break down your boxes and flatten them by slicing through the packing tape, even the small ones. No need to remove the tape and stickers; those get filtered out after the cardboard is turned into pulp. Some jurisdictions require that you tie flattened cardboard together with string or tape.

As with all commodities, the cardboard market fluctuates. When the price of cardboard is high enough there is often a problem known as cardboard poaching. That's when people other than the contracted waste haulers pick up baled cardboard that has been put out on the street. Businesses contract with waste haulers to pick up their garbage—including valuable cardboard—so courts have found that beating the legitimate carters to the punch is illegal fencing.

I learned about cardboard poaching in San Francisco in my twenties when I managed a record store. We would sometimes get garbage tickets for cardboard with our address on it found dumped in other parts of the city. After going to garbage court twice, I learned about the world of cardboard poaching and disruptions caused by sudden changes in the price of cardboard.

Important side note: Frozen food boxes are usually not recyclable! They have a thin layer of non-recyclable plastic coating sprayed on them to protect them from condensation.

PLASTIC & MULTILAYER DELIVERY ENVELOPES
NOT RECYCLABLE

Plastic film delivery envelopes—and any delivery envelopes lined with plastic bubbles—are not recyclable. Some delivery companies claim that plastic delivery envelopes made purely from plastic are accepted at store drop-off recycling programs where plastic films are accepted, but it's unclear whether store programs accept the envelopes and whether the envelopes put in bins at stores are actually recycled.

I'll say it again: **Plastic delivery envelopes and delivery packages lined with plastic are not recyclable.** This is a very big deal given the popularity of online shopping. Improving the recyclability of delivery packaging needs some serious work!

PAPER DELIVERY ENVELOPES

RECYCLABLE

Paper delivery envelopes are recyclable so long as the paper isn't lined with plastic. If shipping labels are easy to remove, you should pull them off.

Paper mailers lined with air bubble padding are also not recyclable and should be put in your garbage bin. The paper is usually glued directly to the bubble padding and can't be removed.

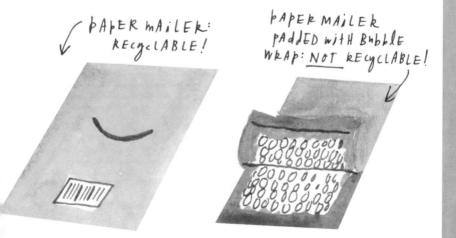

✓ PAPER MAILER:
RECYCLABLE!

PAPER MAILER
PADDED WITH BUBBLE
WRAP: NOT RECYCLABLE!

PLASTIC STRAWS
NOT RECYCLABLE

Many of us have probably seen the video from 2015 of the sea turtle with the straw up its nose. Straws and stirrers are one of the top ten items picked up at beach cleanups, and seeing a plastic straw being pulled from a turtle's nose sparked a big movement away from single-use plastic straws.

Another reason to avoid plastic straws is that they're not recyclable. The awkward, slender shape of straws makes them impossible to capture in the recycling machinery. Even if the straws *were* captured, they are typically made from #6 or #5 plastic that no one wants to buy.

Compostable or biodegradable plastic straws aren't any better. (See page 76 for more details.)

There are more and more single-use straws on the market made from alternative materials that have a better chance at composting than compostable plastics. Alternative straws made from paper, hay, grass, and pasta could be good options—and more are under development. Reusable straws are an even better option and they are generally made from metal, glass, or silicone. They often come with handy long brushes to keep them clean, and collapsible silicone straws can pair with tiny carrying cases.

STRAW ↑

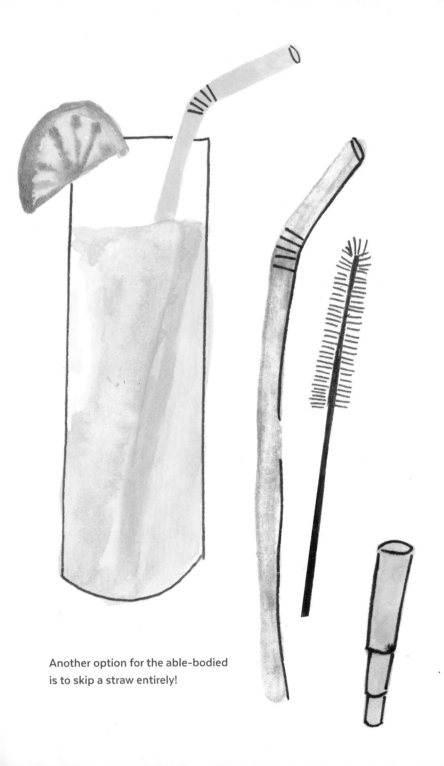

Another option for the able-bodied
is to skip a straw entirely!

COLORFUL PLASTIC PARTY CUPS
NOT RECYCLABLE

When people buy these standard colorful plastic cups for a party, they often feel justified because they can put their cups in the recycling bin. It's kinda like they didn't even use them, right? No.

Most colorful plastic party cups are made from rigid PS #6, which has no domestic recycling market. That means that no one wants to buy that material, and all those cups go to landfills.

Tips

- Use every sturdy cup in your house for the party. (Wine in a coffee mug or jar is fine among friends.)

- Wash and reuse the plastic party cups you already have.

- Buy some extra glasses. (Hit up a thrift store!)

- Rent cups. (Many caterers do this, and a few small businesses have popped up that specifically offer cups for parties and festivals.)

- If you really need plastic cups, maybe look for clear PET #1 instead.*

* Clear plastic party cups can be made of PET #1 or PS #6. The cups made from clear PET are more likely to be recycled than any PS cups. (See page 24 for more information.)

FOAM COFFEE CUPS
NOT RECYCLABLE

Most people want to call this a Styrofoam™ cup, but Styrofoam™ is a registered trademark of DuPont (and the Dow Chemical Company before it) used for foam building-insulation materials. Foam foodware (cups, plates, trays, etc.) is made from a slightly different material and doesn't fall within the trademark. Dow has spent a great deal of money keeping tabs on the high-profile misuses of the term and sending cease-and-desist letters. Advocates trying to ban foodware and packaging made of this material have to use less obvious descriptions: foam, expanded polystyrene, and the acronym EPS.

At recycling facilities, foam is light and breaks up into pieces—which makes it difficult to recover and it sometimes ends up contaminating other recyclables. It's difficult to remove from paper since they're both lightweight. Foam coffee cups and foodware are also very problematic forms of litter—they are easily blown out of trash cans and other containers, even when disposed of properly. EPS pollution is also a particularly pervasive problem in the marine environment. Polystyrene floats and degrades into smaller and smaller pieces, which aquatic animals easily mistake for food and nesting material.

Foam coffee cups are not recyclable. They're made of PS #6, a resin that virtually no one wants to buy. EPS is even worse than normal rigid PS because it's pumped full of air that needs to revert to dense, rigid polystyrene before it can be recycled. It just doesn't make economic sense to recycle, so why is anyone even trying?

The biggest manufacturer of foam foodware in the U.S. has spent millions on lobbying and lawsuits to encourage cities to recycle foam foodware rather than banning it, in a last-ditch attempt to maintain a market for their product.

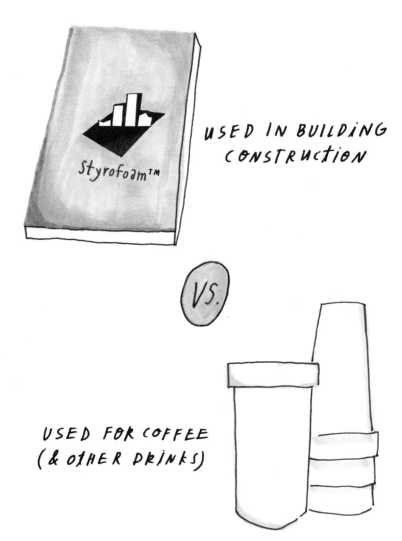

USED IN BUILDING CONSTRUCTION

Styrofoam™

VS.

USED FOR COFFEE
(& OTHER DRINKS)

PAPER COFFEE CUPS
NOT RECYCLABLE

In the paper-recycling process, hot water is used to break down paper into fibers. Paper coffee cups are made from short paper fibers that are lined with a thin plastic coating, and hot water is exactly what coffee cups are made to withstand. Most of the short fibers from coffee cups slip through the holes in paper-recycling filter screens, and along with the plastic lining, mostly end up in the wastewater emitted from the recycling facility. This might even contribute to microplastics in the wastewater.

Most curbside recycling programs don't accept paper coffee cups, but if they do, keep in mind that paper cup recycling is far from efficient (only a few fibers might actually get recycled!). If you recycle your paper cup, remember to rinse it out before recycling— a half-full latte could cause huge contamination issues! Even better, bring a reusable mug or Thermos.

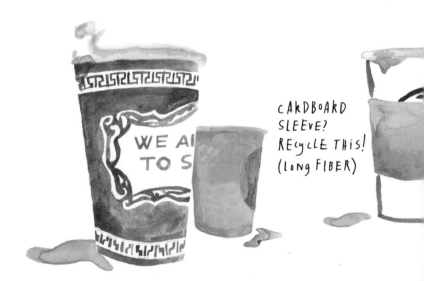

cARDBoARD
SLEEvE?
REcycLE THiS!
(loNg FIBER)

COFFEE CUP LIDS
NOT RECYCLABLE

Coffee cup lids are usually made from polystyrene (resin #6), which isn't valuable on the recycling market and is not processed domestically.

PLASTIC
WATER BOTTLES AND CAPS
RECYCLABLE

Plastic water bottles are usually made from clear PET #1, which is consistently one of the most valuable types of plastic on the recycling market. Recycled PET (also called RPET) can be recycled into new beverage bottles again (and theoretically again).

PET and HDPE #2 bottles are as recyclable as you can get for plastic, but they can be made unrecyclable when covered by a shrink sleeve. Shrink sleeves are plastic films generally made from PETG (a much less valuable type of PET) or PVC. The shrink sleeves can make the bottles not sortable by optical scanners at recycling facilities, because the camera is often blocked from seeing the bottle's resin. Try to avoid plastic bottles with shrink sleeves, especially sleeves that cover most of the bottle. If you buy a product with a shrink sleeve, remove the sleeve and trash it before recycling the bottle.

Green PET bottles have less of a market, so avoid them.

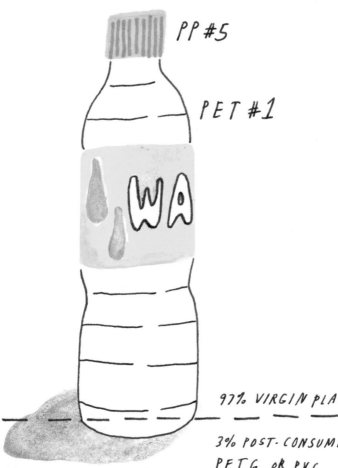

PP #5

PET #1

WA

97% VIRGIN PLASTIC

- - - - - - - - - - - - -

3% POST-CONSUMER SCRAP
PETG OR PVC

Source: 2016 Environmental Protection Agency report

REMOVE SHRINK SLEEVES
& PUT THEM IN THE TRASH

Also, look for bottles without shrink sleeves.
(Evian just announced a "naked bottle"!)

THE BoTtLE cAp DEBATE

Should you leave the bottle cap on when you recycle plastic bottles? Yes!

Some people worry that when water bottles with caps are squished into bales at recycling facilities, the caps could become a dangerous projectile. Don't worry, bottles are in the confines of the baler machine when they are squished, so that's not an issue. A few municipalities ask for lids to be removed (including Warwick Township, Pennsylvania), but the vast majority of jurisdictions ask to have lids placed back on bottles so that they can be captured for recycling.

Orphaned plastic water bottle caps (that aren't attached to a bottle) should be put in the trash. Plastic bottle caps are too small to capture on their own—they usually fall through the disc screens and end up with the glass—so leaving the cap on the bottle allows recycling facilities to capture them. The plastic resin type from the bottle is separated from the plastic resin type from the cap through a float-sink test (see page 112).

The main concern with plastic bottle caps has less to with recycling and more to do with plastic pollution. If you've ever been to a litter cleanup at a beach, you know that plastic bottle caps are a most-often-found item. Ocean advocates are pushing for innovative product redesign of beverage bottles to attach the cap (a.k.a. "leash the lid") to the bottle.

Recycling tip: Don't smash or flatten plastic bottles because recycling machinery is designed to capture plastic bottles that are shaped like bottles. Flattened bottles might end up getting mixed in with recycled paper at some facilities.

LEASH the LID!

TO CAP OR NOT TO CAP

THE FLOAT-SINK TEST

Plastic PET water bottles are recycled with caps intact and shredded into plastic flakes, then the float-sink test is used to separate the resins: PET #1 (from the bottles) sinks, while PP #5 (from the caps) floats.

The majority of the flakes are PET, which is usually much more valuable than PP.

Another reason why shrink sleeves are bad: PETG and PVC both have a specific gravity greater than 1, so they sink in a float-sink test. The shredded PETG gets mixed in with shredded PET and contaminates the product, making it worth less. Also, labels often get stuck to the bottles—even when shredded—and some of the PET can't be used.

PILE of SHREDDED
PLASTIC BEVERAGE
BOTTLES

PP from BOTTLE CAPS
FLOATS
(SPECIFIC GRAVITY ~.90)

PET FROM BOTTLES SINKS
& is RECOVERED
(SPECIFIC GRAVITY ~1.3)

ALUMINUM SODA CANS
RECYCLABLE

The average aluminum beverage can has a higher recycling rate and a much higher percentage of recycled content than glass or plastic beverage bottles. Part of the reason for this is that aluminum cans are capable of being continuously recycled into new aluminum cans without diminishing the quality of the material. Aluminum cans are also far more valuable as a commodity than glass or plastic, and they often end up subsidizing less valuable recyclables in curbside bins. Aluminum represents about 1% of the recyclable household waste stream by volume and yet represents a very significant amount of the stream's value.

Question: If you're bringing beer or soda to a party, should you buy cans or glass bottles? Here are the factors that I weigh and I usually end up buying cans, but the decision is up to you!

- Aluminum cans are infinitely recyclable, and aluminum is very valuable on the commodities market compared with other materials.
- Plastic six-pack rings are not recyclable, but now some beer cans are packaged in boxes!
- There are potential public health concerns with BPA and other phthalates (hormone-disrupting chemicals) in the plastic film liners of aluminum cans for carbonated beverages. Many brands have replaced BPA liners with other liners, but have not disclosed the chemical makeup of the new liners.
- Aluminum is made from bauxite ore, and bauxite mining has profound human rights consequences (particularly in Guinea!). So if you use aluminum, definitely recycle it to prevent needless mining!
- If your beverage container will not be recycled, then go with glass bottles—glass is more inert.

VALUE PER TON OF RECYCLABLE MATERIAL

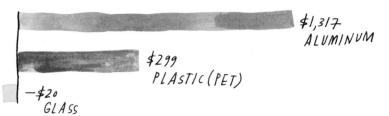

$1,317
ALUMINUM

$299
PLASTIC (PET)

−$20
GLASS

VIRGIN ALUMINUM - 27%

POST-INDUSTRIAL - 23%

POST-CONSUMER - 50%

SCRAP - 73%

CONSUMER RECYCLING RATES OF BEVERAGE CONTAINERS

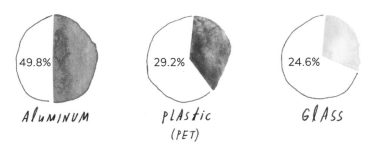

49.8%
ALUMINUM

29.2%
PLASTIC
(PET)

24.6%
GLASS

Source: The Aluminum Association (values based on pricing from 2017–19, and PCR data based on 2016 U.S. Environmental Protection Agency report).

GLASS BEER BOTTLES
RECYCLABLE (BUT HAVE ISSUES)

A 2016 report from Moore Recycling estimated that 81% of the U.S. population had access to local recycling programs for glass beverage bottles. There are a few reasons why some cities don't accept glass curbside: the added fuel costs to transport glass as it is super heavy, the problem of broken glass contaminating paper and cardboard, and the opposite problem of glass becoming contaminated by small pieces of plastic, paper, and metal. Contamination is less of an issue at modern recycling facilities, but prevention requires up-front investment. The average price for mixed colored glass is close to zero, and the average price from 2017 to 2019 was -$20, which means that recycling glass costs only slightly less than paying a tipping fee to send glass to a landfill. This value could be improved if glass is sorted by color by customers, as in Germany (see page 52), and more end markets are developed.

Whether glass is accepted for recycling tends to be regional because there are a limited number of glass-manufacturing plants and glass-processing plants spread unevenly around the country. There are even regional variations for different colors of glass. For example, the green glass often used for wine bottles is generally in higher demand in California, and the amber glass often used for beer bottles is generally in higher demand on the East Coast. Secondary uses for recycled glass include tile, sand blasting, concrete pavements, and Alternative Daily Cover (see page 84). These secondary uses aren't recycling; rather, they're downcycling, because that glass isn't recycled back into a new glass product.

Many people prefer glass for food and beverages because glass has no chance of leaching chemicals into food, but as you can see, glass recycling has many challenges. Reusable glass is a great option when it's available. Oregon's bottle-deposit pilot program BottleDrop Refillables for glass beer bottles, which are filled and distributed locally, is the ultimate in sustainability.

AVG. RECYCLE CONTENT FOR A GLASS BOTTLE IS 23%

METAL BEER BOTTLE CAPS
RECYCLABLE (BUT HAVE ISSUES)

Metal beer bottle caps are usually made of steel. They're small so they often fall through the holes in the screens and end up with the glass, but if they make it through the initial screens, they sometimes get around the "smalls" issue, because they can be sorted with *magnets*! Unfortunately, the magnets also often attract small batteries too, which can complicate things. It's definitely far from a 100% chance that your small metal bottle cap will make it through the process, but it's probably still worth tossing caps into your recycling bin. Even though they're lined with plastic, the metal is often recovered because it has a high value.

Super Recycler: Eureka Recycling in Minneapolis, Minnesota, offers the following advice for metal beer bottle caps: First, make sure that the bottle cap is made from steel by seeing if a refrigerator magnet sticks to it. If so, place your metal bottle caps in a steel can (like a soup can) that has part of the lid still partially attached, loosely close the lid (take care not to cut yourself on the edge!), and put it in the recycling bin—then your caps will be more likely to be captured and sorted.

MILK JUGS
RECYCLABLE

PLASTIC JUGS

Plastic milk jugs are made from HDPE #2 "Natural" plastic, meaning that no color has been added. The commodities market varies, but HDPE Natural is usually the most- or second-most-valuable plastic (along with PET #1). A decline in milk consumption in general, as well as less milk being sold in plastic jugs, has made HDPE Natural resin less abundant on the recycling market. At the same time, some beauty product lines have begun using post-consumer recycled HDPE for product packaging as it's very versatile.

REUSABLE GLASS BOTTLES

The availability of this service is limited because you need to live near a dairy processor and a bottler (to wash and reuse the bottles), as milk expires quickly and also because glass bottles traveling long distances means more greenhouse gas emissions. If you live in a community where reusable glass milk bottles are an option and it's not too cost-prohibitive (often the cost difference is a refundable deposit), *go for it!* I personally prefer having milk in glass rather than in plastic as it sits in my refrigerator. It's extremely important to reuse rather than recycle these glass bottles; glass bottle recycling has its own issues (see page 116).

PLASTIC CAPS SHOULD BE LEFT ON CARTONS & JUGS

MILK CARTONS
ONLY THE PAPER LAYER IS RECYCLABLE

PAPER MILK CARTONS

Only a little over half of curbside recycling programs accept milk cartons. Paper milk cartons are made from paperboard coated on both sides with a thin layer of polyethylene (PE) plastic. Many people feel better buying milk in a paperboard carton rather than a plastic jug, because they don't want plastic touching their food. However, polyethylene plastic touches the milk in both types of packaging—it's just a difference in the volume of plastic being used to make the container. These cartons need to be sent to a specialized mill where special chemicals are used to separate the paper fibers from the carton's coating. Although it is more work to separate the paper fibers from the plastic, the result is very long and strong fibers—perfect for making tissue paper. Only the paper layer is recycled; the plastic layers and the plastic cap are usually not recycled. Some paperboard milk cartons are really Tetra Paks (see next page).

THE VERDICT

Use reusable glass bottles if you can. If you live in a community that doesn't accept cartons, definitely buy plastic milk jugs—and probably buy plastic milk jugs regardless because they are more recyclable than cartons.

A rule of thumb: The bigger the package, the lower the impact on the environment—so gallon jugs are better than half-gallon cartons.

COCONUT WATER CARTONS
ONLY THE PAPER LAYER IS RECYCLABLE

Most coconut waters and soup broths are now sold in aseptic packaging, often made by the packaging company Tetra Pak. Tetra Paks are multilayer packages made of thin paperboard, plastic, and aluminum (like a paper milk carton plus an aluminum layer). They are manufactured using a specialized process in which food is sterilized separately from packaging, and the final product is shelf stable, meaning that it does not need to be refrigerated until after it is opened.

Aseptic containers, including Tetra Paks, are currently accepted by most recycling programs that take paperboard milk cartons and are usually categorized as cartons. These cartons need to go to a special paper mill where the paper fibers are extracted from the paperboard layer, and there is major controversy about whether enough paper mills want them. The paper fibers are long and desirable for making new products, but they require special processing and the plastic and aluminum layers are usually disposed of—except for at least one specialized mill that makes wall insulation. This doesn't meet the Federal Trade Commission's definition of recycling as the FTC requires that the entire product or package, excluding minor incidental components, be recyclable in order to make an unqualified claim of recyclability. A qualified claim of "only the paper layer is recyclable" would be more accurate.

JUICE POUCHES
NOT RECYCLABLE

Juice pouches are generally made from multilayer material consisting of plastic and aluminum that have no chance of being effectively recycled in curbside bins. Those tiny straws are also not recyclable.

Instead of buying individual-portioned juice pouches, consider purchasing juice in bulk (or make juice at home) and using a reusable drink container. I recommend frozen juice concentrate, especially if you're already buying juice that's made from concentrate anyway.

Juice boxes, on the other hand, are recyclable in some jurisdictions that accept milk cartons. If you live in a community with a dual-stream recycling system, cartons go in the bin with the metal/glass/plastic rather than in the bin for the paper.

PLASTIC COFFEE PODS
NOT RECYCLABLE

As of 2019, 41% of Americans owned a single-cup coffeemaker. Coffee pods have become one of the best examples of unnecessary single-use plastics, with a treatise published in *The Atlantic* and a viral "Kill the K-Cup" video on YouTube. There was even a class-action lawsuit filed over whether coffee pods can be labeled as recyclable.

Plastic coffee pods are of course too small for most standard recycling facilities and will likely end up falling through the screens with orphaned bottle caps (see page 110) or "surfing" on other materials and mixing in where they don't belong. Because coffee pods are made of several parts, further insult to customers happens when they take the time to separate the various parts of the pod before attempting to recycle it—only to have it end up as residue. Even if coffee pods could be sorted successfully, they are generally made of PS #6 or PP #5, neither of which has sufficient domestic reprocessing capacity.

Some companies, namely Nespresso, use single-use aluminum pods rather than plastic. Aluminum usually gets captured by the Eddy Current Separator, but aluminum pods would likely fall through disc screens and end up with glass, so they would have to be sorted out at a glass facility. Sims Municipal Recycling in New York City has a pilot project to sort the aluminum pods out of the glass with special machinery, but these pods would not be captured elsewhere.

LID: COATED ALUMINUM FOIL
SOMETIMES RECYCLABLE

PLASTIC CUP
NOT
RECYCLABLE

COFFEE GROUNDS & FILTER PAPER
COMPOSTABLE

WINE CORKS
NOT RECYCLABLE

Wine corks are not recyclable curbside. Corks are made from wood, from cork oak tree bark, but corks do not have the type of wood fibers used for making paper. Natural wine corks are compostable in some curbside composting programs. Also, some stores have drop-off bins for corks, which are collected and downcycled into soles for shoes, corkboards, and cork flooring.

Plastic wine corks? Not recyclable either. They're too small to be captured in recycling machinery. Plastic wine corks are usually made from Other #7 plastic, so even if they were captured they would have no value on the commodities market.

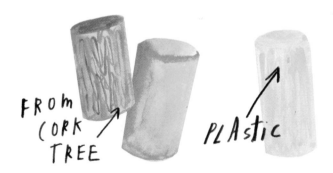

FROM CORK TREE

PLAstic

GLASS JELLY JARS
WITH METAL LIDS
RECYCLABLE (BUT HAVE ISSUES)

A glass jelly jar with a metal lid is recyclable in most jurisdictions, but both the jar and the lid have issues. Take the metal lid off and put both in your recycling bin—there's no need to remove the paper label from the jar. The lid is made from steel and will be captured by the drum magnet at the recycling facility if it makes it that far. Because the lid is flat and relatively small, it might not get sorted properly, but it has a decent chance compared with tiny beer bottle caps! (See page 52 for issues related to glass recycling.)

This is also a stylish reuse item. I like to keep a few of these around for leftovers and partially used vegetables (like half a tomato), but they can also be used as terrariums or homemade candleholders. Or, instead of the dreaded non-recyclable plastic party cups, try using these cute jelly jars.

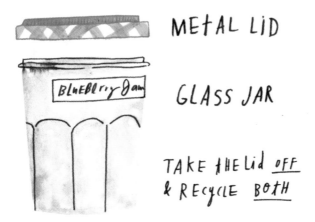

METAL LID

GLASS JAR

TAKE THE Lid OFF
& RECYCLE BOTH

PLASTIC FORKS
NOT RECYCLABLE

Similar to straws, plastic forks and other plastic utensils have a slender awkward shape that doesn't make it through the machinery at recycling facilities. Also, plastic utensils are usually made out of rigid PS #6, which no manufacturers want to buy on the recycling market.

Compostable or biodegradable plastic forks aren't any better (see page 76 for more details). Single-use wooden utensils are a step better because they are capable of degrading in the natural environment—but avoiding single-use completely is still best.

Here are some other tips for avoiding single-use utensils:

- If you order takeout or delivery, tell them you don't want utensils—you probably already have a collection of unwanted plastic silverware somewhere in your kitchen! If a restaurant follows your request, thank them, and if not, remind them next time.

- If you work at an office, keep a set of silverware at your desk and wash them after use.

- If you're traveling, carry a set of silverware in your purse or bag (if you carry a knife, make it a butter knife). Fancy bamboo options with their own carrying cases are also available if you want to be extra classy.

- Instead of buying new silverware, just reusing an existing plastic fork works too.

- Tip from my mom: She carries a spork in her purse—it's three utensils in one!

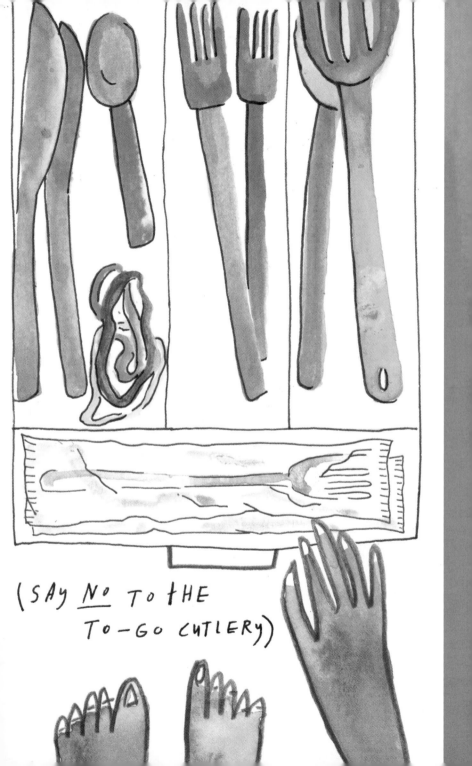

(SAY _NO_ TO tHE TO-GO CUTLERy)

PLASTIC TAKEOUT FOOD CONTAINERS
NOT RECYCLABLE

Plastic takeout food containers are made from a variety of plastic resins—usually PET #1, PP #5, or PS #6—and the lower numbers are generally more recyclable than the higher numbers. Thermoform plastic is a much less valuable form of resin than bottles and jugs. Thermoforms aren't accepted for recycling in all jurisdictions and don't have much of a market (see page 22), but if your jurisdiction accepts them, make sure to remove all food scraps.

Plastic boxes of arugula and lettuce at the supermarket are thermoforms and also subject to this fate. I love arugula, but I have to remind myself of the non-recyclability of thermoforms when I'm in the produce aisle. I usually opt for unpackaged lettuce, and sometimes make a special trip to a farmer's market or Eataly.

Black plastic isn't recognized by optical scanners and thus recycling facilities can't sort them, but the same style of clear or white food containers are capable of being sorted out into bales for recycling. Plastic takeout food containers have a low likelihood of being sorted and baled then finding a buyer, but at least give them a bit of a fighting chance by avoiding the black food containers!

BLACK pLAStic CAN'T BE READ BY OPTICAL SORTERS & THUS CANT BE SORTED

COATED-PAPER TAKEOUT FOOD CONTAINERS
NOT RECYCLABLE

Coated-paper takeout containers are similar to paper coffee cups, but they're even more likely to contribute to some serious food contamination. They're not recyclable. Food contamination is a much bigger issue at paper mills (where these would be routed) versus at metal/glass/plastic sorting facilities (where plastic containers would be routed). Stray food scraps and grease-soaked takeout containers can contaminate entire bales of paper.

The good news is that many composting programs accept coated-paper takeout containers in food-scrap composting bins. The system is far from perfect, though, and some coated-paper or fiber-based compostable containers behave better than others at compost facilities. There's also a concern that toxic PFAS "forever chemicals" are sometimes used in the lining of coated-paper and fiber-based takeout containers, as well as fast-food wrappers and other food-contact materials.

Several local and state laws have been adopted to ban PFAS in takeout food packaging.

PIZZA BOXES
RECYCLABLE

Pizza boxes are recyclable in most places, but only so long as you take all the pizza out and as long as the box is not too greasy.

Pizza boxes are made from corrugated cardboard, which has long fibers and is recyclable. Grease is a nasty contaminant, though, and when it gets mixed in with the pulp, it lowers the quality of the recovered fiber.

- Always remove *all* food. Check whether the lid is greasy—if so, you can't recycle it.

- If only the bottom part of the box is greasy, you can rip off the lid of the box and recycle only that.

- If you want to go the extra mile, you can surgically snip off the greasy bits with scissors and recycle the clean parts.

- Always remove the box liner (hopefully that liner caught most or all of the grease!).

- The pizza box liners and greasy boxes can be composted in many curbside food-scrap composting bins; otherwise they should be put into the trash.

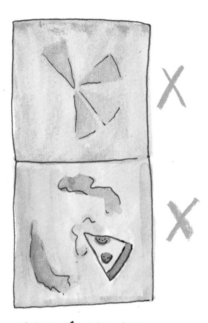

FOOD & GREASY
CARDBOARD DO
<u>NOT</u> GO IN THE BIN

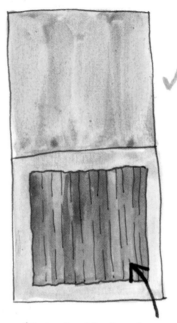

ALSO REMOVE ANY
GREASE LINER
BEFORE RECYCLING

kEtCHUP & CONDIMENt PACKEtS

GENERALLy ITEMS MADE FROM LAyERS OF MATERIALS (THIN FOIL & pLAStiC) AREN'T RECyCLABLE

NOT RECYCLABLE

Standard ketchup and condiment packets are constructed from multilayer laminates that use both plastic and metallic foil. These aren't easily recycled, as the layers are pretty much impossible to separate. With clear plastic soy sauce packets, you avoid the multilayer issue, but the packets still use flexible, film packaging that is small and contaminated with food. These don't make economic sense to recycle, and no recycling programs accept ketchup packets.

Avoid single-use condiment packets when you can, and if you get them, they belong in the trash rather than in the recycling.

HOT
spicy SAucE foR ANythiNG

SOy SAUCE
GOOD STUFF
PRESERVATIVES
YUM

KETCHUP
TOMATO

No NEED FOR THESE

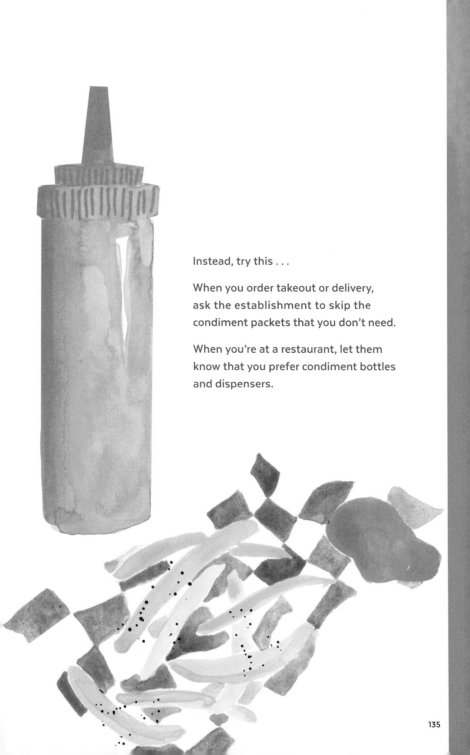

Instead, try this . . .

When you order takeout or delivery, ask the establishment to skip the condiment packets that you don't need.

When you're at a restaurant, let them know that you prefer condiment bottles and dispensers.

CONDIMENT CUPS
NOT RECYCLABLE

The biggest issues with condiment cups and lids are that they are small and almost impossible to capture in the recycling process. They end up as residue that falls through the holes in the recycling machinery.

When you consider using a plastic condiment cup at a dine-in restaurant—maybe "salad dressing on the side" or pico de gallo or maple syrup—think about it falling through the holes of recycling machinery and not being recycled. The best thing that you can do is figure out a way to avoid single-use condiment cups. (Put it directly on your plate or ask for a saucer or small bowl.)

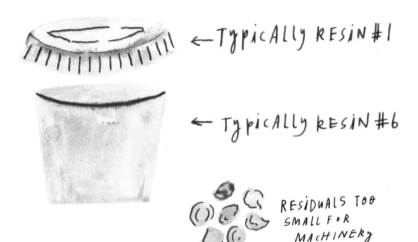

←TYPICALLY RESIN #1

← TYPICALLY RESIN #6

RESIDUALS TOO SMALL FOR MACHINERY

ALTERNATIVES "for HERE"

METAL CERAMIC

GO COMMANDO!

SKIP A cup AND put tHE pico
<u>diRectly ON tHE TACO</u>

SOUP CANS
RECYCLABLE

Soup cans (a.k.a. tin cans) are made from steel. They are recyclable and almost all curbside recycling programs accept them. A recycled steel can is capable of becoming a new steel can, and steel cans typically contain at least 25% recycled steel. A recycled soup can can also become part of a bridge, a car, or a ship. The price per pound of steel is much less than that of aluminum, but the metal still consistently has buyers.

It is necessary to clean all food contents from a soup can before placing it into the recycling bin. There's no need to remove the label from the can prior to recycling. The lids to the cans are accepted by most curbside programs, and it's best to insert the lid back into the can after it has been emptied and rinsed clean. (Watch out for the sharp parts!)

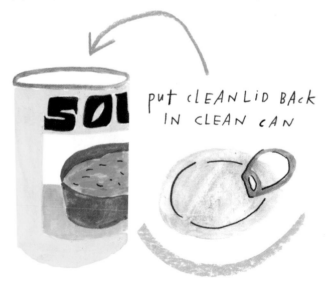

put cLEANLiD BAck IN CLEAN cAN

CEREAL BOXES
RECYCLABLE

Cereal boxes made of lightweight cardboard are accepted by most recycling programs. You should be able to recycle your cereal boxes in programs that accept other colorful paper products such as magazines, junk mail, and other food boxes. The same cannot be said of most frozen food boxes, which are not recyclable because they have a thin layer of plastic to prevent freezer burn.

Most cereal liner bags are made from HDPE #2 film. Rigid HDPE bottles and jugs are high-value recyclables, but plastic film, including liner bags like these, are not recyclable in curbside bins, but some grocery store drop-off plastic bag recycling programs accept films like these (see page 92 for more information).

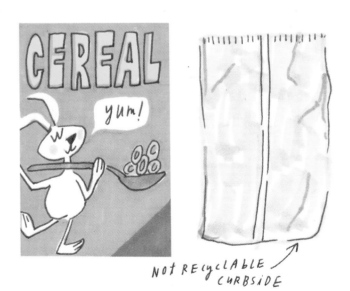

NOT RECYCLABLE CURBSIDE

COCKTAIL PEANUT CANS
NOT RECYCLABLE

One general rule of recycling is that items are recyclable if they are made of one type of material. This can of cocktail peanuts is an example of an item that is not recyclable as a whole—plastic lid, coated-paper canister, metal rim and bottom—and requires dismantling for successful recycling.

WARNING: If you choose to dismantle something, be very careful! Also, be certain to weigh the costs and benefits of dismantling, as this may be a frustrating process with little yield. (No pressure!)

Alternatives:

- Consider buying your nuts in bulk; many grocery stores have this option.
- Purchase nuts in glass jars where available.

Full disclosure: My husband loves a particular brand of cocktail peanuts, so this conversation is very real (and slightly contentious in my household).

LID:
#2 HDPE PLASTIC
PROBABLY NOT
RECYCLABLE

PULL-TAB:
MULTILAYER
NOT RECYCLABLE

TOP RIM:
METAL
RECYCLABLE

BODY:
COATED PAPER LINED
WITH MULTILAYER
NOT RECYCLABLE

BOTTOM:
METAL
RECYCLABLE

CHIP BAGS
NOT RECYCLABLE

Most chip bags are made from aluminum laminated with PP #5, also known as metalized polypropylene. Multilayer packaging, if labeled at all, falls within Resin Identification Code #7, for "Other" non-recyclable material. While each material may be recyclable in itself, the mixture of all those materials together cannot be recycled. Multilayer packaging—pouches, crinkly bags, granola bar wrappers, and baby food pouches, to name just a few—should go into the trash.

CANDY WRAPPERS
PROBABLY NOT RECYCLABLE

The vast majority of candy wrappers are made of a mix of materials, mostly plastics, and usually can't be recycled. The general rule is that the fewer materials something is made of, the more likely it is to be recyclable. Certain candy wrappers that are made from only one material, or from materials that you can separate, may have a chance of being recycled.

A mix of plastic films, not recyclable →

Paper and aluminum foil: Recycle the paper if it's completely free of candy. Tiny foil won't end up being sorted correctly on its own, but ball it in with other foils if you have them. ←

↖ A mix of plastic films, not recyclable

Same as with the other foils ↙

AEROSOL WHIPPED-CREAM CANS

RECYCLABLE (BUT HAVE ISSUES)

Aerosol cans themselves can be recycled and they are currently widely accepted, but it's what's inside them that is the problem. The cans are pressurized with a propellant that when released from the can atomizes the product and produces a spray. The contents of aerosol cans should be emptied before the can is recycled. When aerosol cans are still filled and are thrown away into the trash, they often explode as the trash gets compacted. This potentially creates extremely dangerous working conditions for your local recycling and sanitation workers.

HOW TO RECYCLE AN AEROSOL CAN

1. Is what's in the can hazardous? Bring it to a household hazardous-waste drop-off program if it contained acutely toxic contents (pesticides, herbicides, or highly toxic solvents).

2. Check to see whether your jurisdiction accepts aerosol cans.

3. Check to see if the can is empty. If you shake the can and hear the liquid inside, spray until nothing comes out.

4. Leave the cap off the aerosol can and place the cap in your recycling bin, if your jurisdiction accepts it.

Aerosol cans are made of either aluminum or steel, so they will be sold and shredded to make new aluminum or steel products.

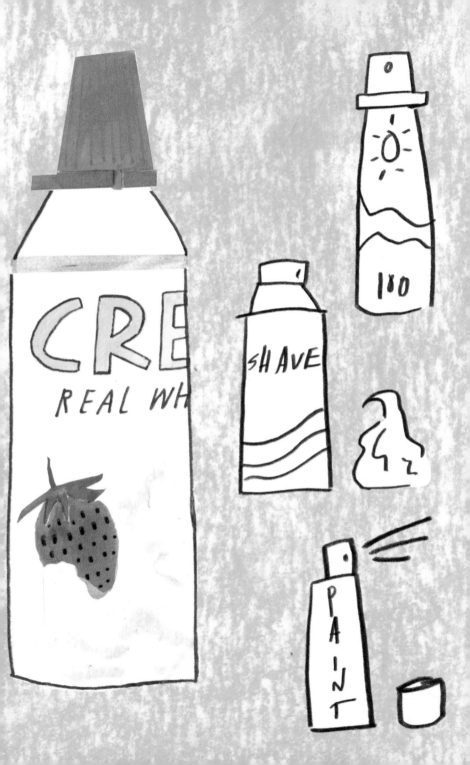

BABY FOOD POUCHES
NOT RECYCLABLE

Baby food pouches are generally made from multilayer material. These pouches are lightweight and convenient, but—unlike PET plastic bottles and glass jars—multilayer pouches have no chance of being effectively recycled.

Plastic bottle caps are generally recyclable only when attached to a recyclable bottle, like a water bottle. The cap here is not recyclable as the pouch is not recyclable. You should place both into the trash.

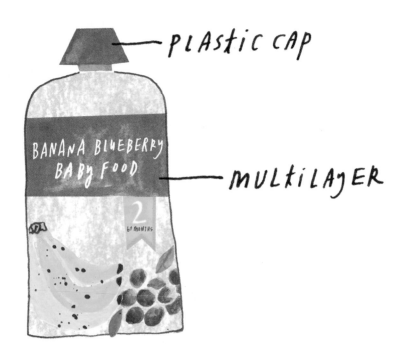

PLASTIC CAP

MULTILAYER

BANANA BLUEBERRY BABY FOOD

2
6+ MONTHS

YOGURT CUPS
NOT RECYCLABLE

Yogurt cups are generally made from either PP #5 or PS #6. Most facilities have limited optical-sorting capacity and instead focus on PET #1 and HDPE #2, which are considered top recyclable plastics in the household stream. PP-generation rates are growing according to some studies, and some recycling facilities sort PP optically, but PP is considered non-recyclable because there isn't sufficient reprocessing capacity. PS is never optically sorted and has no value on the commodities market.

When you shop for yogurt, consider glass yogurt cups. Even better, buy large containers of yogurt rather than several small cups. Larger containers are easier for recycling facilities to sort and bale, and they're made of less plastic overall. If you're lucky enough to live in a community with reusable glass yogurt cups (with a deposit system), opt for those!

MESH CLEMENTINE BAGS
NOT RECYCLABLE

Mesh bags are made from either HDPE #2 or PP #5 film and are not recyclable curbside. Similar to plastic carryout bags, mesh bags get caught in recycling machinery. Put these bags into the trash unless you can find another use for them (maybe a bag for beach toys, or taped to the top of a flower vase to hold flowers in place?).

Try to avoid mesh bags and consider bringing your own produce bag to buy loose citrus instead.

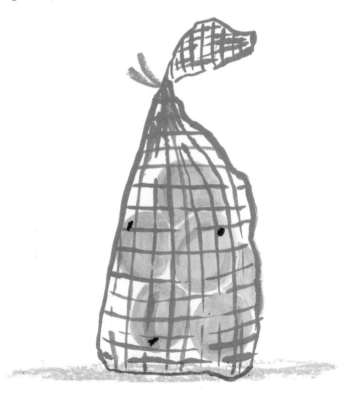

PAPER Egg CARToNS
RECYCLABLE

Paper egg cartons are recyclable. They are made from molded pulp, which is a mix of recycled paper and cardboard. Before recycling, make sure that the carton is clean and dry. Food residue will contaminate the recycling process—if you place eggs back into the carton after cracking them, the carton is no longer recyclable due to the food residue. If food residue gets on part of your paper carton, tear that part off and throw it away (or compost it), then recycle the rest.

Foam egg cartons are made from expanded PS #6 (a.k.a. EPS) and are not recyclable. Clear plastic egg cartons are usually made from a type of PET #1 called thermoform. Thermoform PET doesn't currently meet the FTC's definition of recyclable (see page 16), but there is some hope if its being recycled in some jurisdictions compared with EPS.

The Take-Home: Buy paper egg cartons when you can, and clear plastic egg cartons are the next-best runner-up.

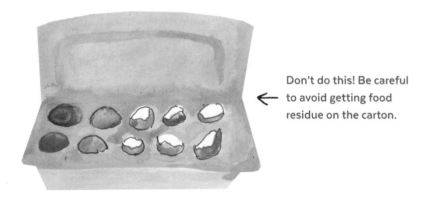

Don't do this! Be careful to avoid getting food residue on the carton.

OFFICE PAPER
SPECIAL NYC EDITION
RECYCLABLE

Paper is generally recyclable as long as it's not waxed or laminated (candy wrappers), coated (some receipts), contaminated (dirty!), or tissue paper (soft stuff, like facial tissues and Kleenex). New York City has a particularly interesting story because it involves something relatable to all New Yorkers—pizza boxes.

1. Use a piece of paper.

2. When you're done with that paper, put it into your curbside recycling bin.

3. The city's sanitation trucks take your paper to the transfer station.

4. Your paper rides on a barge to the paper-recycling facility on Staten Island.

5. The paper has its initial sorting—stuff that's not paper or cardboard is pulled off by hand.

6. It's off to the cauldron of steaming hot water and paper, where paper is broken down into individual fibers.

7. The clean pulp then goes through giant rolling dryer machines to remove water, resulting in new paper.

8. Some of that new paper becomes corrugated (the stuff with the zig-zagging internal layers).

9. And then . . . the paper sent to Staten Island becomes . . . pizza boxes!

PAPER TOWELS & TISSUES
NOT RECYCLABLE

Paper towels, tissues, napkins, and paper plates have short fibers, which make them undesirable for recycling—for two reasons:

REASON #1

Food, grease, and even bodily fluids dirty these products. They cannot be "cleaned" during the recycling process. (Some of these materials are compostable, but not if contaminated with bodily fluids.)

REASON #2

A very-low-grade short-fiber paper is used to make these products. Paper-recycling facilities cannot capture these short fibers in their screens, and they will end up in the wastewater. Tissue paper that you would use to wrap a gift also falls into this category.

Tissue boxes and paper towel cores are recyclable—put them into your paper recycling bin.

Tip: Use cloth napkins and towels instead of paper towels and tissues when you can!

LONG FIBERS
RECYCLABLE*

 PAPER BAGS

 OFFICE PAPER

NEWSPAPERS & MAGAZINES

 CORES FROM PAPER TOWELS & TOILET PAPER

SHORT FIBERS
NOT RECYCLABLE**

 PAPER TOWELS

 PAPER PLATES & NAPKINS

 TISSUE PAPER

 PAPER TAKEOUT CONTAINERS

* Except most frozen food boxes can't be recycled because they're sprayed with plastic coating.

** Most of these can be composted if they're not contaminated with bodily fluids.

ALUMINUM FOIL
RECYCLABLE (BUT HAS ISSUES)

If you recycle aluminum foil, make sure to *remove all food* and scrunch up the foil into a ball. Ideally, scrunch all of the aluminum foil that you use that week into one big tight ball. Larger balls of aluminum are closer to the size of an aluminum can, and recycling machinery is designed to capture aluminum cans.

If you don't scrunch the aluminum foil into a ball, it may end up with the paper recycling if you live in a community with single-stream recycling, as it's lightweight and flat like paper. If you only loosely scrunch it, the foil will break up into smaller pieces, and it probably won't be sorted.

EAT TACO

CLEAN tHE FOiL

SCRUNCH
& RECYCLE

CLOTHING HANGERS
NOT RECYCLABLE

Clothing hangers are not recyclable in the vast majority of jurisdictions. Many recycling facilities are not prepared for the pointy edges and curved ends of clothing hangers. They are considered "tanglers" and they can easily damage machinery.

Clothing hangers are usually made from metal, plastic, wood, or a blend of materials. Even if your recycling program says it accepts scrap metal or all plastic, don't put metal or plastic hangers in your bin unless your local program specifically mentions them. Wire hangers are made from steel and have a thin plastic coating to keep them from rusting. If you have a very large number of metal hangers, you could try selling them to a scrap yard, but that's very unlikely.

WE ♡
OUR CUSTOMERS

The best way to dispose of clothing hangers is to find a drop-off program at a recycling center, or take them to a local dry-cleaner or a thrift shop that accepts them. If you have a lot of nice hangers, you can also try posting them on your local Craigslist "free stuff" list or your local Buy Nothing Project group.

If all this fails and you have to dispose of them in the trash, you can remove the paper from dry-cleaning hangers and recycle that.

CLOTHING & FABRIC
NOT RECYCLABLE

Clothing and fabric are not recyclable. They are "tanglers," defined as any item that can wrap around recycling-processing machinery. Tanglers are very problematic contaminants for recycling.

So just donate it, right? Much of the clothing that is donated to major U.S. thrift stores ends up being shipped internationally. Fast fashion has meant that the supply of used clothes is greater than demand—and excess supply ends up in the landfills of developing countries. To dispose of unwanted clothes and to ensure they don't end up in a landfill, strive to have them reach someone who'll appreciate them. Consider donating at strategic times for specific needs, like waiting to donate your heavy coats and scarves to a winter coat drive. (And don't forget to read page 215 for more on buying vintage!)

As for used bedding, call your local animal shelters. Many animal shelters accept used towels and blankets for use as bedding for lonely dogs and cats. For fabric and damaged clothing, you can also look for textile-recycling programs that turn textiles into insulation material. That's downcycling, but at least it's something.

SHOES
NOT RECYCLABLE

Like clothes, shoes are never recyclable. Just think about it—shoelaces tangle enough when we wear them. Recycling facilities certainly aren't equipped to handle that.

Shoes can be donated to a thrift store or dropped off at a clothing-collection bin at farmer's markets in some areas. However, a pair of shoes still may end up going to a landfill, depending on the style, condition, and market. If shoes are in good shape, you can try selling them through a consignment shop or a vintage clothing store, or online on fashion-resale sites (like Poshmark).

Good shoes are also one of the top items requested by organizations serving the homeless. Please get in touch with your local shelters and pass on your unwanted sneakers, boots, and outdoor shoes. They won't go unappreciated.

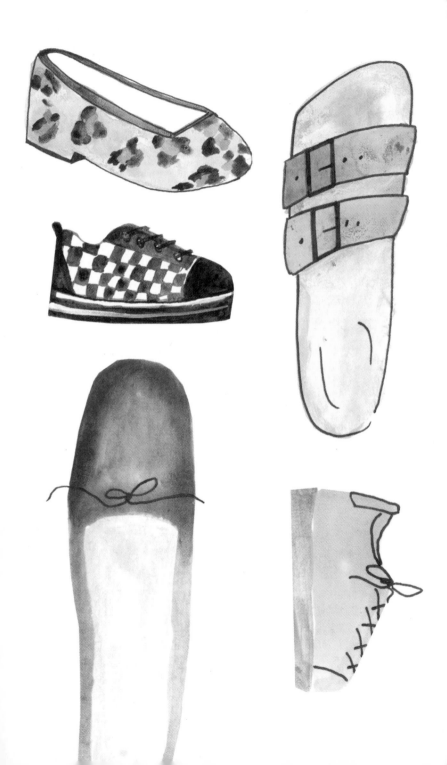

EYEGLASSES
NOT RECYCLABLE

Eyeglasses are not recyclable curbside because they are made from mixed materials. Eyeglasses consist of a frame, lenses, screws, and sometimes nose pads. Lenses for eyeglasses are made from coated plastic or glass, and frames can be made from an even wider variety of materials. Most plastic eyeglass frames are made of zyl or propionate, so even without lenses or screws, these resins are never recyclable curbside.

The best thing to do with your used eyeglass frames is to donate them at a drop-off program. Lions Club International collects donated eyeglasses for distribution overseas, and their website includes a searchable map of drop-off locations near you.

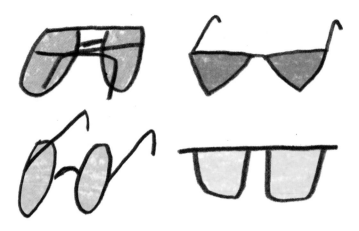

DISPOSABLE CONTACT LENS
BLiSTER PACKS
NOT RECYCLABLE

Disposable contact lenses generally come in blister packs. Blister packs are composed of pre-formed plastic packaging with perforated sheets for tearing off individual contact lens cases. They are made with a backing of aluminum foil or plastic, and often with a multilayer mixture of both.

Some jurisdictions that accept all rigid plastics accept the pre-formed plastic part of blister packs, but only if the perforated sheets are intact and all the backing is removed. Even if they are accepted, a clean and fully intact sheet of pre-formed plastic blister packs is rarely sorted and baled at recycling facilities.

multilayER

PLAStic

On the other hand, small pieces of plastic that hold only one or two lenses have zero chance of being effectively recycled curbside. The same goes for the multilayer backing—it also has no chance of being effectively recycled curbside. Just put them into the trash.

SHAMPOO BOTTLES
RECYCLABLE

HDPE #2 SHAMPOO BOTTLES (RECYCLABLE)

Shampoo bottles are generally made from HDPE #2, which is recyclable. Natural HDPE—meaning clear and slightly cloudy—has one of the highest values on the recycling commodities market. Colored HDPE also has a value, but it's much less—so opt for non-colored HDPE bottles when you have the option. Large shampoo bottles are recyclable; small shampoo mini-bottles are generally not recyclable because "smalls" are impossible to sort at most recycling facilities.

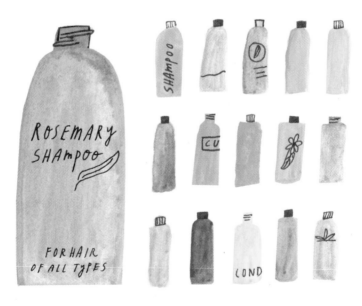

ROSEMARY
SHAMPOO

FOR HAIR
OF ALL TYPES

SHAMPOO

CU

COND

33.8 oz. BOTTLE ⟵ 1 oz. BOTTLES

COLORED PET #1 SHAMPOO BOTTLES (NOT RECYCLABLE)

Recently, some companies began switching from HDPE #2 to PET #1. There is virtually no market demand for colored PET containers. Try to avoid colored PET bottles when possible.

Also, look for shampoo bottles that use post-consumer recycled (PCR) content. Some high-end sustainable brands are using PCR content, and they'll usually say so on the bottle. For example, most of Aveda's bottles are made of at least 80% PCR HDPE as part of their responsible-packaging commitment.

A general rule is that buying in bulk is better. Consider buying a liter-size shampoo bottle. Not everyone can afford the up-front investment of a giant bottle of shampoo, especially if you use fancy shampoo, but if you can, you'll save money in the long run as the price per ounce is much lower for large bottles.

Super Recycler: Avoid using hotel mini-bottles of shampoos and lotions. One big shampoo bottle made of HDPE is *much* more likely to get sorted at recycling facilities than thirty-three small mini-bottles. The mini-bottles are cute, and I'm always tempted to try new shampoos, but for whenever you travel, refilling one mini-bottle from your bigger bottle at home is so much better for the environment.

Even better: Use a shampoo bar! Several companies, including Lush, are now selling shampoo bars, so you can skip packaging entirely.

RX BOTTLES
NOT RECYCLABLE

Amber-colored prescription bottles are generally made from PP #5, and their white lids are made from HDPE #2. There are two issues with these bottles. The first issue is that many recycling programs don't accept PP. If a recycling facility uses optical scanning for sorting plastic, each scanner is assigned to sort out only one type of plastic resin, and many facilities don't have enough scanners to sort out PP. If the bottles aren't sorted out, they end up in bales of mixed plastic that is very unlikely to be sold and manufactured into a new product. The other issue is that some of these bottles are borderline too small for recycling machinery.

If your recycling program accepts all rigid plastics, make sure to empty the bottle, keep the lid on, and remove the label if you can.

Some pharmacies and grocery stores have drop-off programs for prescription bottles, sometimes in conjunction with drug-disposal programs. If your recycling program can't process prescription bottles and you can't access a take-back program, always consider reuse. I use empty orange pill bottles to sort nails in my toolbox.

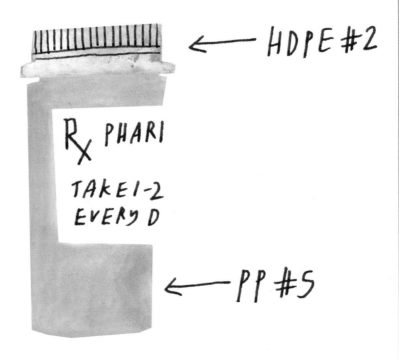

← HDPE #2

R_X PHARI

TAKE 1-2
EVERY D

← PP #5

REUSE!
NAILS, BUTTONS, ETC.

TABLETS BY
EVERY 4-6
FOR PAIN.

LiGHTERS
NOT RECYCLABLE

Cigarette lighters are not recyclable. Traces of lighter fluid could contaminate other valuable materials, even when your lighter fluid has run out. Also, lighters are made from a mix of materials, and the plastic shell is generally made from a blend of resins. Mixed materials are rarely recyclable.

FACE MASKS
NOT RECYCLABLE

DO NOT RECYCLE FACE MASKS!

Most single-use face masks are made from a non-woven PP #5 fabric, but they can also be made from PET #1 and a variety of other resins. None of them are recyclable curbside. When you put them into your recycling bin, someone at the recycling facility is forced to touch your potentially contaminated personal protective equipment. That's just plain rude!

If you use a single-use face mask, the trash can is your only option. Whenever it makes sense, try opting for a reusable cloth face mask that you can wash and use over and over again.

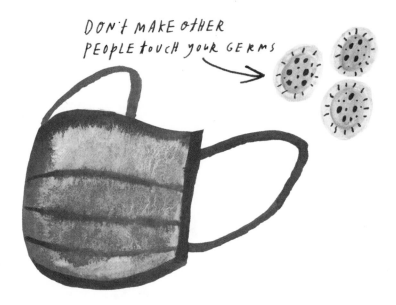

DON'T MAKE OTHER PEOPLE touch youR GERMS

TOOTHBRUSHES
NOT RECYCLABLE

Toothbrushes are not recyclable curbside due to their size and because they're made of mixed materials (plastic handle, often a plastic grip, nylon bristles, maybe a metal staple).

There are drop-off programs for some toothbrushes, but they are corporate-funded and PR-driven. The time and energy that it takes to separate the materials and extract the resin doesn't make economic sense when there is so much higher-value plastic that is going to landfills, because no one is buying that material. Consider trying a wooden or bamboo toothbrush—there are even some available with boar hair bristles (if you're into that).

TOOTHPASTE TUBES
NOT RECYCLABLE

Toothpaste tubes are not recyclable curbside. They're made from multilayer material—contaminated with the bits of toothpaste that remain in the tube—and an impossibly tiny plastic cap.

LIGHT BULBS
NOT RECYCLABLE

No light bulbs are recyclable. Incandescent light bulbs don't contain toxic chemicals, so you can throw them out in the regular trash. They're fragile—you'll want to wrap the bulbs in other packaging to protect yourself against tiny broken glass shards.

Fluorescent tube lights and compact fluorescent (CFL) light bulbs contain mercury, and they should not be put into your recycling bin or the trash. Mercury is a valuable material but it's a hazardous material. According to the EPA, as long as the bulb is intact, there is no evidence that a well-made CFL or fluorescent light bulb causes health problems—but mercury is released if a bulb breaks. CFLs must be disposed of at drop-off locations, including retailers like Home Depot and Lowe's, as well as at local household hazardous waste (HHW) programs.

CFLs do have big advantages, so they're worth the extra caution. CFLs beat regular incandescent light bulbs by almost 15,000 more hours of life, so some of the mercury issues are offset by reduced emissions.

LED lights are another great option for reducing energy use, with efficiency rates even higher than those of CFLs. LEDs don't contain mercury, so look for local drop-off locations, but as a backup they can be put into the trash.

INCANDESCENT BULB

RECYCLE = NO

TRASH = YES

COMPACT
FLUORESCENT (CFL)
BULB

RECYCLE = NO

TRASH = NO

MUST BE BROUGHT TO A
DROP-OFF PROGRAM

(LOWE'S IS A GOOD OPTION)

BATTERIES
NOT RECYCLABLE

When determining how to dispose of a battery, the choice is whether to put it into your trash can or to bring it to a drop-off program. One big deciding factor is whether the battery is rechargeable or single-use. **Recycling curbside is never an option for batteries.**

SINGLE-USE

Single-use batteries are now made of non-hazardous metals and can be disposed of in your regular trash in the U.S.—*not* in the recycling bin. Until the mid-1990s, single-use batteries that contained mercury were treated as hazardous waste by the federal government, and in California, throwing away any type of battery is illegal to this day.

RECHARGEABLE

Rechargeable batteries of any kind should not be placed into your trash can. Rechargeable batteries contain heavy metals that are hazardous to the environment. To dispose of rechargeable batteries (including lithium-ion batteries), you must bring them to an at-store drop-off program. To prepare batteries for recycling, you should tape over the positive (+) terminal with masking tape to avoid—you guessed it—a significant fire hazard.

LITHIUM-ION

Lithium-ion batteries are a type of rechargeable battery that is commonly used for a variety of portable electronics. **Lithium-ion batteries can generate large amounts of energy and pose a serious fire risk.** This is such a dangerous problem that recycling facilities are now having a hard time getting insurance. Turn the page for more information on lithium-ion batteries!

LiTHIUM-IoN BATTERIES (AGAiN!)

NOT RECYCLABLE

It's worth repeating: **Don't put lithium-ion batteries—or any device containing lithium-ion batteries—into your curbside trash or recycling bin!** These small items are the leading cause of fires in sanitation trucks and at recycling facilities.

FIRES cAN
HAPPEN!

FLASHLIGHTS
NOT RECYCLABLE

Flashlights are made of mixed materials, which sometimes include those pesky lithium-ion batteries that burn down recycling facilities and cause general mayhem. The plastic shell of a flashlight is never recyclable. It's generally made of either injection molded PS #6 or a unique blend of specialty plastic resins. The light bulb is also not recyclable, and the small pieces of metal embedded in the plastic aren't capable of being sorted.

Before disposing of a flashlight, always remove its batteries and bring them to your local battery drop-off.

GARDEN HOSES
NOT RECYCLABLE

Don't recycle garden hoses! Hoses are tanglers that get caught in recycling machinery. Garden hoses are one of the most problematic and expensive contaminants at recycling facilities.

What can you do with that old cracked or leaking garden hose? Consider turning it into a soaker hose by puncturing it with holes—or give it away to someone on Craigslist's "free stuff" list or your local Buy Nothing Project group who may want to use it as a soaker hose.

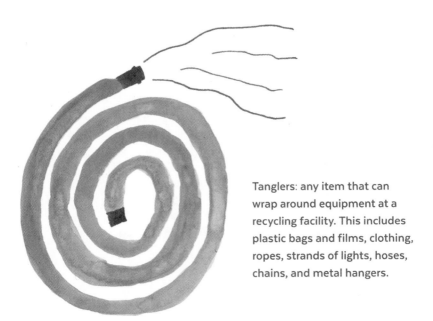

Tanglers: any item that can wrap around equipment at a recycling facility. This includes plastic bags and films, clothing, ropes, strands of lights, hoses, chains, and metal hangers.

EXTENSION CORDS
& CHRISTMAS LIGHTS
NOT RECYCLABLE

Don't put extension cords or Christmas lights into your recycling bin—they're tanglers that get caught in recycling machinery! Your best bet is to dispose of them at a local electronics-recycling drop-off program. Check to see whether Christmas lights are accepted, and if not, look for a special Christmas-lights drop-off program (sometimes there are seasonal pop-ups).

When electrical cords are recycled, the cords are chopped up, and various methods are used to separate the materials. Magnets pull out steel wire, while vibrating surfaces and airflow are used to separate the lightweight plastic casing from the heavier metal. These specialized techniques extract high-value metals, the most valuable of which is copper wire. Unfortunately, many of the techniques are labor intensive and thus are often shipped abroad to locations where fewer environmental and worker protections are in place.

CELL PHONES & LAPTOPS
NOT RECYCLABLE

Cell phones and laptops are not recyclable curbside. They are made of a mix of materials, including toxic heavy metals in the circuit board, and they likely have a lithium battery that could start fires when tossed around at a waste disposal or recycling facility.

Cell phones should be brought to drop-off programs at electronics retailers.

Remember: Never put batteries or anything with a battery into your recycling bin!

THE TAKE-HOMES ABOUT RECYCLING

WHAT'S SUPER RECYCLABLE?

Metal, especially aluminum cans

Paper products with long fibers (cardboard, paper bags)

Plastic PET #1 and HDPE #2 bottles and jugs (not colored)

Glass bottles and containers (where accepted)

DON'T RECYCLE THESE!

Tanglers: These are likely to get caught in the gears at recycling facilities (plastic films, electrical cords).

Smalls: These are likely to fall through the holes in recycling machinery (plastic forks, unattached bottle caps).

Batteries: Never recycle batteries!

Light bulbs: Never recycle these either!

Contaminated paper: Food and grease make paper unrecyclable, but sometimes you can compost it.

Multilayer packaging: This is not recyclable unless it's a carton with a paper layer—the paper is the only layer that's recyclable.

EPS, a.k.a. Styrofoam™

TIPS ON HOW YOU CAN RECYCLE BETTER

Rule of Thumb: Recycle it if your jurisdiction tells you to, even if you know that there isn't a market.

- Remember to screw bottle caps onto their bottles before recycling.

- Buy in bulk rather than in single portions; bigger containers are easier to sort and bale.

- Products that are made from one material are more likely to be recycled than products made from mixed materials.

- Disassembly can be helpful (except don't remove caps from plastic bottles). For example, remove shrink sleeves from bottles, or rip the greasy part off your pizza box and throw that part away.

- Items should stay in their normal shapes to maximize their chances of being sorted properly. For example, bottles should remain bottle-shaped instead of flattened. (Cardboard boxes are the exception to this rule—flatten them!)

- Bigger products with compact shapes are easier to sort: Buy big containers of yogurt rather than a lot of single-serve yogurts.

- Try to buy less stuff, buy less plastic, and especially buy fewer plastics that are hard to recycle. Avoid EPS, black plastic foodware, colored PET bottles, multilayer, and single-serve anything!

And the biggest take-home of all:

We need better reduction and recycling policies, and mandating post-consumer recycled content is key!

VOTE FOR
POLITICIANS
WHO CARE
ABOUT THESE
ISSUES!

VOTE
FOR
CHANGE

(PLEASE
PLEASE
VOTE)

THE HUMAN IMPACTS OF SHIPPING RECYCLABLES INTERNATIONALLY

Recycling Exports: Why China?

For the last quarter century, China handled nearly half of the world's recyclables. Its plastic-scrap import business began as a grassroots effort among poor villagers in search of livelihoods. They began to import and process a growing supply of recycled scrap material coming from America's West Coast. Economies of scale developed in some regions that focused on certain materials. For example, Wen'an County and Shandong Province became plastic recycling zones. According to one estimate, roughly sixty thousand small family farms were converted into family-run plastics-recycling facilities.

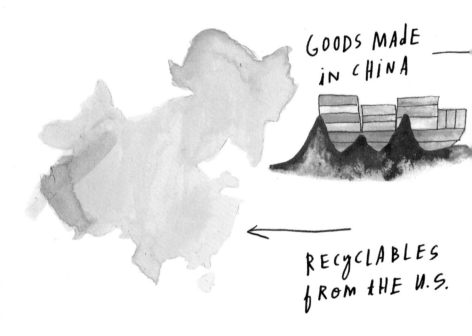

GOODS MADE
iN CHINA

RECyCLABLES
fRoM tHE U.S.

Shipping recyclables from the U.S. to China made economic sense due in large part to the trade deficit. The U.S. buys a lot more stuff from China than vice versa, which means that shipping containers often returned to China empty. Rather than having ships return empty, steep discounts were offered for shipping goods back to China. It made economic sense to fill the ships with scrap materials for China's recycling market. That's why we talk about China so specifically when talking about recycling exports.

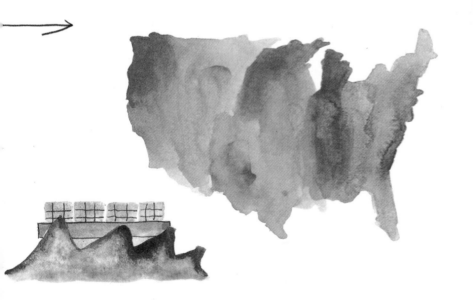

China's National Sword Policy

In China, bales of low-value scrap plastic were cherry-picked by low-wage workers doing labor-intensive work, like removing shrink-wrap sleeves from bottles by hand with a razor blade. The best of these materials were processed into recycled plastic nurdles (the raw material for new plastic). The remainder was often burned in nearby fields or dumped into nearby waterways. Many of the low-value plastic recyclables that you carefully sorted into your curbside bin in the U.S. had a good chance of being burned in someone's backyard in China.

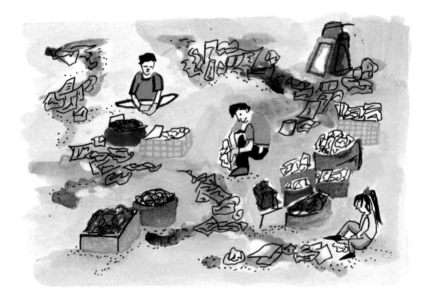

In 2013, China instituted their Operation Green Fence policy, which restricted the types of import materials that would be accepted. In 2017, China announced an even stricter National Sword policy,

which disallowed certain low-value plastics and mandated that customs workers reject shipments with more than 0.5% contamination. The reasoning behind the policy was that China's industrial economy had grown, and China's government wanted to recycle more of its own domestic waste and to reduce air and water pollution by moving away from low-value recycling.

After the National Sword policy was announced, the recycling market for most low-value plastics disappeared practically overnight. Contamination rates of recyclables vary from place to place, but China's strict standard of less than 0.5% contamination essentially operated as a ban on the import of plastic waste to China. U.S. recycling facilities started to fill with bales of low-value plastic recyclables, because they no longer had a consistent buyer. Rather than selling the materials that had been sorted and baled, many U.S. recycling facilities started paying for the incineration and landfill costs of low-value plastic waste. This became a major news story—"The Recycling Crisis"—and brought mainstream attention to the issue of how recycling works and what was failing.

One of the main rationales behind China's new standards was to create incentives for recyclers to better manage domestic streams of municipal waste. We need better mechanisms for collection and sorting, but we need to look beyond collecting and sorting materials. If we consider how products are designed in the first place, and how we process them to maximize recycling, we can minimize the amount of low-value materials and packaging that we need to dispose of.

China's import of scrap plastic dropped from 12.6 billion pounds in 2017 to 110 million pounds in 2018, but China is still among the top importers of scrap plastic in the world.

Source: *Resource Recycling*

The Human Impacts of Shipping Recyclables Internationally

From an environmental and humanitarian perspective, China's National Sword policy was in many ways a welcome change. It brought to light that much of the plastic waste sent to China was not effectively recycled and was instead processed by low-wage workers without the health, safety, or environmental protections mandated in the U.S. We were simply outsourcing the problems associated with these materials.

When people think of recycling low-value plastics, I want them to know that their plastic waste has likely been landfilled or incinerated in the U.S., or has gone to a sorting lot in a developing country in the Global South. China has strict labor laws in place, but the problem has been a failure to enforce laws to protect disempowered rural workers. Similarly, clean air and clean water protections in China are often unenforced. In Wen'an, one of China's plastic-recycling zones, studies have shown that heavy metal pollution from plastic-waste recycling is high enough to cause risks associated with cancer in children. In Shandong Province, groundwater is contaminated from years of plastic processing, and families are now forced to buy barrels of drinking water. These examples show that how Americans handle our waste—and particularly items that we label as recyclable—should be seen as a humanitarian issue as well as an environmental issue.

China's stricter regulations do not mean that these issues have been solved. It likely means that some of America's low-value plastic scrap material will continue to go to developing countries in the Global South that are still willing to accept it, including Vietnam and Malaysia, and increasingly countries in Africa. Much more needs to be done to ensure that America's low-value plastics aren't contaminating countries with even less infrastructure than China.

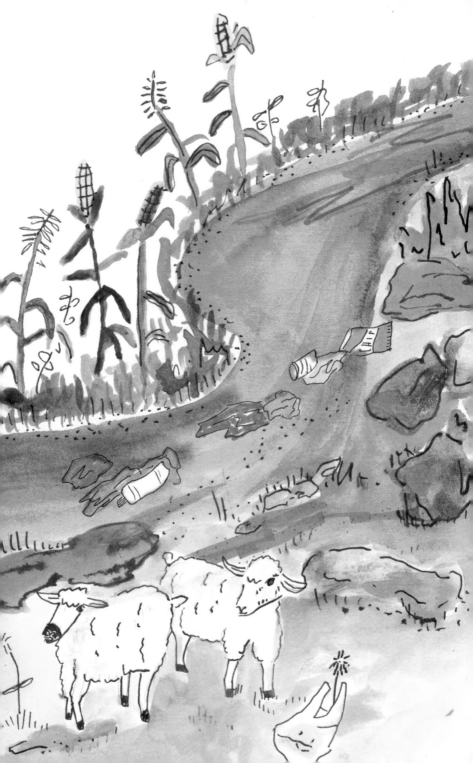

Ban International Export
of Plastic Waste

While a ban on the international export of plastic waste does not fully address the impacts of shipping recyclables internationally, it's an important step toward real conversations about what recycling means and what materials have a market to be recycled domestically, and goes a long way toward a more just and transparent waste-management system.

The Basel Convention regulates the way member countries (called parties) can export hazardous materials to other countries. It was originally adopted in an effort to prevent developed countries in the Global North from exporting and dumping dangerous hazardous waste materials into developing countries of the Global South. In 2019, reflecting the emerging understanding of the environmental and health harms from plastic waste, parties to the Basel Convention agreed to reclassify plastic waste under the categories defined by the convention to increase transparency in the plastics trade. Effective in 2021, member states are now required to obtain prior informed consent from the destination country for shipments of plastic waste, largely destined for recycling, except for clean pre-sorted single-polymer shipments. This is a significant change from previous allowances under international law, whereby countries and companies were free to ship plastic waste overseas with little disclosure or oversight.

The U.S. is a signatory to the Basel Convention but has not implemented any of its ratification requirements through federal legislation, and is the sole signatory which has failed to do so; as a result, the U.S. may not participate fully in Basel Convention

discussions or decision making. Nevertheless, the U.S. was one of the few countries that objected to the change regarding prior informed consent for plastics—and even objected to the change being implemented under the Organisation for Economic Co-operation and Development (OECD), which would normally automatically incorporate any amendments made to the Basel Convention.

While the prior informed consent is in place for all Basel Convention parties as of 2021, the impact of the objection by the U.S. is not yet clear for U.S. overseas exports. A ban on international export of plastics waste has also been proposed at the federal level as part of the Break Free From Plastic Pollution Act (see page 234).

In 2020, Waste Management, along with several other waste-hauler companies, announced that they are no longer exporting plastic waste outside North America.

SIDE NOTE

I highly recommend the film *Plastic China* to see unsanitized footage of life at a family-run plastic recycling facility in China. It's not just a story of plastic; it's a heartbreaking family drama featuring a little girl named Yi-Jie. Some of the early footage from this film is said to have inspired China's stricter scrap-import standards.

PLAStics IN tHE OCEAN (& EVERYWHERE!)

Plastic Smog

Eleven million metric tons of plastic waste enter the ocean every year. Without significant action, plastic will outweigh fish in the ocean by 2050. Many people are intrigued by the idea of cleaning the ocean as a simple fix to the plastic pollution crisis without having to change our behaviors, but our focus should be on reducing plastic consumption and thus reducing plastic pollution from flowing to the ocean.

The Pacific Garbage Patch has been described as an island. In truth, plastic pollution in the ocean is less like an island and more like a smog or soup. Plastic in seawater photodegrades and breaks up, quickly becoming too small to capture. These tiny microplastics, along with plastic in various states of degradation, create a plastic smog that is much harder to clean up than a plastic island.

The plastic pollution issue is not limited to oceans and waterways—research has shown that microplastics exist even in dust in the high desert. However, plastic pollution has been particularly impactful on the ocean.

Portuguese man-of-wars are marine hydrozoans
(closely related to jellyfish) that sail along the open ocean.

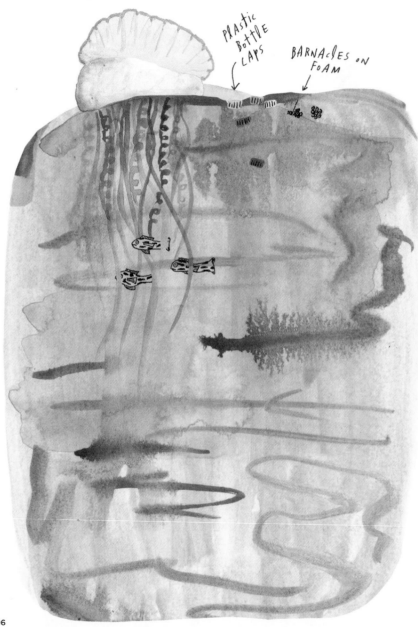

Floating Animals and Plants in the Open Ocean

In the Atlantic Ocean, floating rafts of a type of seaweed called sargassum can stretch for miles across the ocean. This floating habitat provides food, refuge, and breeding grounds for an array of animals, such as fishes, sea turtles, marine birds, crabs, shrimp, and others. Sargassum serves as a primary nursery area for a variety of commercially important fishes, including mahi-mahi.

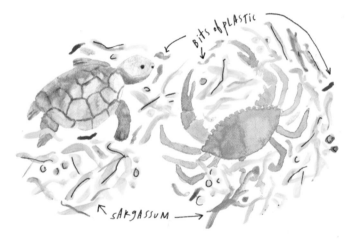

Even thousands of miles from land, large pieces of plastic and tiny microplastics are entwined in the sargassum.

Sargassum is just one example of floating animals and plants in the open ocean. There are countless other examples, including the Portugese man-of-war. Ocean cleanup schemes attempt to skim plastic from the surface of the open ocean and ignore that plants and animals float there too. Skimming the surface of the open ocean would remove ocean life along with plastic, which is why the focus needs to be on source reduction.

Turtles and Albatross

Impacts of marine debris, particularly entanglement by and/or ingestion of plastic, has been documented for 914 marine species. Certain single-use plastics cause distinct harms to specific marine animals—sea turtles and albatross being two prime examples.

Plastic carryout bags look a lot like jellyfish in the water column. It's widely believed that sea turtles often mistake floating bags for jellyfish and ingest them. Scientists estimate that one third of leatherback sea turtles have ingested plastic. Sea turtles are also susceptible to getting plastic straws stuck in their noses (see page 100).

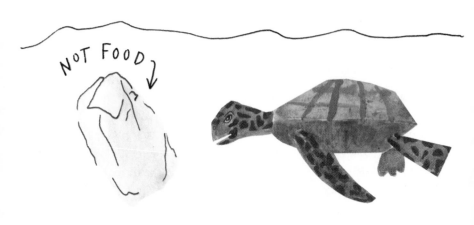

Plastic bottle caps are made of polypropylene, and when littered in aquatic environments, they often float on the water's surface due to their relatively light density. Bottle caps floating on the ocean's surface look like food to many animals, including fish and birds, most notably the Laysan albatross. One study estimates that nearly 90% of the world's seabirds have eaten plastic.

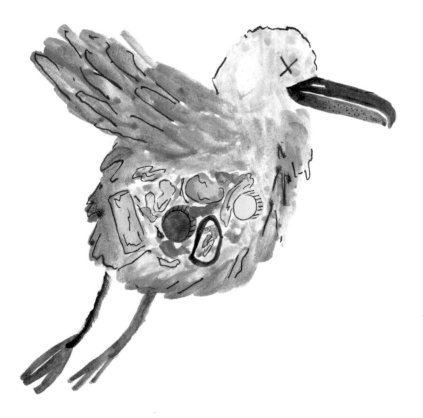

Beach Cleanups

Beach cleanups help prevent plastic from entering the ocean. They're great for directly preventing plastic pollution, and getting involved can help you make a few new friends who care about the issue!

Many beach cleanups also categorize and count the items picked up, which shows what's littering our beaches and helps guide policy. The trend in beach cleanups is to also capture the brand identification for items that are picked up. Many organizations fighting to reduce plastic pollution in the ocean, including the Surfrider Foundation, are quick to point out that beach cleanups are not the ultimate solution. The ultimate solution is source reduction.

Harbor Cleanups

Rivers are a large source of plastic pollution in the ocean. To capture plastic before it reaches the ocean, we need to collect it at river mouths and in harbors.

Baltimore has a good example of this. Mr. Trash Wheel (officially known as the Inner Harbor Water Wheel) is a collection device designed to intercept trash at the mouth of the largest tributary feeding into Baltimore's Inner Harbor. Two booms floating in the water guide the trash flowing from the tributary toward Mr. Trash Wheel's mouth, where a conveyor belt slowly carries the trash up a ramp and deposits it into a dumpster.

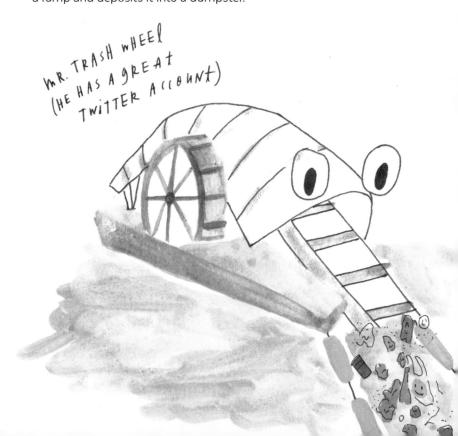

MR. TRASH WHEEL (HE HAS A GREAT TWITTER ACCOUNT)

Marketing of Ocean Plastic

Clothing and shoes made from ocean plastic is a big trend. These products are usually more expensive and their marketing portrays the entire product, or at least the majority of the product, as made from plastic waste that was captured from the ocean. That often isn't the case.

Plastic that's collected directly from the ocean is often so degraded that only a small portion is salvageable. Much of what's marketed as ocean plastic is actually "ocean-bound" plastic, defined by some companies as plastic collected near a coastline, which ignores that at least some of that plastic could be captured by existing waste management systems. Given all of this, ocean plastic products are seen by many as a distraction that takes attention and resources away from source reduction, while only cleaning up a tiny fraction of ocean plastic.

The marketing of ocean plastic is unlikely to go away, but the claims being made should at least be clear so that people know what they're buying. Also, plastic-based clothing sheds tiny microfibers and contributes to microplastic pollution, so natural fibers are often a better option when making purchases with plastic pollution in mind.

UNCLEAR CLAIM
"MADE FROM OCEAN PLASTIC"

CLEAR CLAIM

"MADE FROM OCEAN-BOUND PLASTIC COLLECTED WITHIN 30 MILES OF A COASTLINE (AT RISK OF BECOMING MARINE LITTER)"

TRIMMINGS
10% OCEAN-BOUND PLASTIC
80% PCR PLASTIC
10% VIRGIN PLASTIC

FABRIC
80% OCEAN-BOUND PLASTIC
20% PCR PLASTIC

PLAStICS FOUND INSIDE

TINY INVISIBLE PLAStICS
INSIDE OYStERS

Plastics on Our Plates

As soon as plastic enters the environment, land or sea, it begins to fragment. Plastic slowly breaks down into smaller and smaller pieces, becoming microplastics—and even tinier nanoplastics. Microplastics are a serious threat to ecosystems and human health in part because of their ability to absorb and concentrate persistent organic pollutants (POPs) and other harmful toxins. Researchers have found that some types of plastic absorb ten times the amount of organic pollutants than other types of plastic, which means that certain plastics are more hazardous to fish than others are.

Marine mammals and fish often mistake plastics for food. Microplastics are also eaten by plankton, the foundation of the marine food chain that is eaten by all marine life. This causes biomagnification, where harmful chemicals accumulate up the food chain. Microplastics, including microfibers, were found in almost all oysters analyzed from the Oregon Coast in a recent study—meaning that we likely eat microplastics whenever we eat shellfish.

Voyage to an Ocean Gyre

I studied zoology as an undergrad at UC Santa Barbara, where I took a full year of aquatic biology classes. That's where I first learned about ocean gyres as places where a large system of wind-driven circular ocean currents converge, causing patches of high biological productivity in the open ocean. Essentially, I discovered that subtropical gyres are important feeding grounds in the open ocean.

A decade later, ocean gyres were in the news for accumulating plastic. In 2013, I had the opportunity to travel to the center of the North Atlantic Gyre—from Bermuda to Newport, Rhode Island. I spent eight days on a seventy-two-foot sailboat with the 5 Gyres Institute, a non-profit research organization. At the time, the plastics industry was saying that the threat of plastics in the ocean was being blown out of proportion by environmentalists. I wanted to know exactly what was out there.

I didn't expect to actually see any plastic bags in the open ocean. They photodegrade quickly into microplastics, and a little sediment or algae will make them too dense to float. Nonetheless, I saw several floating plastics bags, including a solitary white shopping bag that had floated 142 nautical miles from Newport. More importantly, all the samples that we collected from our manta trawl nets that skimmed along the top of the open ocean came back with microplastics. The microplastics were tiny colorful fragments the size of sand grains—and they were entwined with ocean life. Seeing these microplastics firsthand gave me a unique vantage point for describing the problem, and reemphasized how important it was to stop plastic pollution at its source rather than cleaning it up in the open ocean.

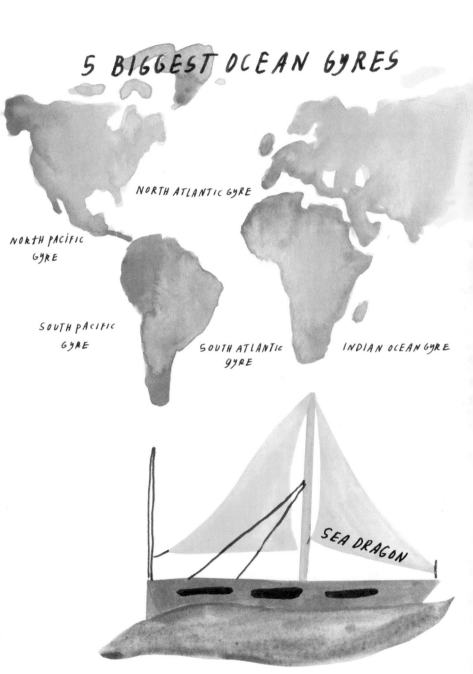

5 BIGGEST OCEAN GYRES

NORTH ATLANTIC GYRE

NORTH PACIFIC
GYRE

SOUTH PACIFIC
GYRE

SOUTH ATLANTIC
GYRE

INDIAN OCEAN GYRE

SEA DRAGON

PERSONAL
SoLutIoNs

Personal Solutions

On a personal level, there is a lot that you can do to reduce your waste, especially plastic. Avoid single-use everything, especially non-recyclable plastic. You've learned that the majority of plastics can't be recycled, and that recycling itself has serious environmental and humanitarian impacts.

Avoid single-use plastic whenever you can: This will always be the best solution.

One of the best ways to avoid single-use plastics is to Bring Your Own (BYO) bag and avoid the need for plastic bags. Several interesting reusable bag options are available, even one that you can wear on your wrist like a bracelet.

pods create
a lot of waste

Bring Your Own Everything

Once you've gotten comfortable with bringing your own bag, expand to bringing your own water bottle, coffee mug, straw, and utensils. Ease into it. Choose one or two items to start. Give yourself a chance to get into the habit. If you work at an office and eat meals at your desk, try keeping your own metal utensils at your desk. This avoids the need for plastic utensils entirely.

If you're going to a party that you expect will have single-use plastic cups, bring your own cup. Not only will you spare one plastic cup from being used, people will also notice that you brought your own cup, and it will very likely be a point of conversation. You might even inspire a few people to bring their own cups to the next party, and the party host could start using reusable cups. This is the power of visible Zero Waste actions.

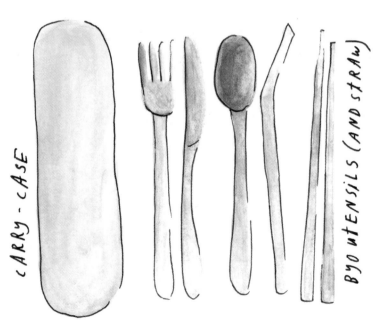

CARRY - CASE

BYO uTENSiLS (AND STRAW)

Next Level: BYO Food Containers

If you're going out to dinner and you think that you might have leftovers, bring a food-storage or Tupperware container. This automatically erases the need for more single-use plastic takeout containers.

The next level: Walk to pick up your takeout food instead of having it delivered, and ask to have your meal placed in your own containers. I lived around the corner from a Chinese restaurant for years, and I would call in my order and bring my vintage pink Pyrex containers to pack the food in. Some states have laws regulating outside containers, so if your food container is rejected, you can ask the restaurant to put your meal on a plate, then you can transfer the food from the plate to your container.

If you feel out of place, take solace in the fact that you're normalizing positive behaviors for others. With the Chinese restaurant, I like to think that I motivated a few other customers to bring their own containers too.

If people take bold actions toward reuse, BYO behavior can be normalized, and we will have a much better chance at adopting policies that mandate reduction and reuse. In just a few years, the culture around waste and recycling can change. We should also support businesses with their own reusable-container programs—like the Just Salad chain in New York City, which offers additional toppings if you buy and reuse the Just Salad bowl.

Buy Food (and Anything You Can) in Bulk

Co-op grocery stores, and even Whole Foods, offer a variety of basic bulk-food items. Co-ops tend to be more accommodating than most chain grocery stores if you want to bring and tare (measure the weight for) empty containers. There's also a new trend with Zero Waste stores, which specifically cater to a Zero Waste lifestyle. These stores tend to be more minimalist and hip than co-ops and are more approachable for some people because they don't require memberships. For example, a store called Precycle in Brooklyn, New York, offers a variety of stylish jars, along with carefully curated bulk-food selections, including kimchi and pasta.

The ultimate example of bulk options is Rainbow Grocery Cooperative in San Francisco. Imagine twelve kinds of peanut butter, four kinds of tortilla chips, and four kinds of fresh pesto, as well as a variety of lotions and shampoos, all available in bulk with most people bringing in their own jars to tare. Rainbow is absolute heaven.

No time to tare? San Francisco-based Goods Holding Company offers stylish glass jars with the tare weight (including the weight of the metal lid) printed directly on the jar.

Tare weight: the weight of an empty vehicle or container

Buy Vintage

Fashion creates a lot of waste. Donating your old clothes is a good practice, but many clothes end up getting shipped to other countries and often end up in their landfills. Giving or selling your clothes directly to someone means that the clothes are more likely to end up as part of someone's wardrobe. Giving away clothing—and other items—on local free lists like Craigslist or Buy Nothing Project allow person-to-person sharing. I personally love browsing the free section of Craigslist just to see what people are offering.

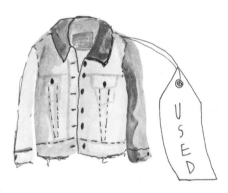

You can help reduce some of that waste by buying vintage clothes. Buying vintage takes more effort than buying new clothes, but vintage clothing apps like Poshmark make it much easier and very transparent to buy and sell clothes online. Finding a favorite local vintage clothing store or thrift shop where you can shop in person can be priceless (and save a lot of delivery packaging). My current favorites are Risk Gallery & Boutique in Brooklyn, New York, and the well-curated Margaretville Hospital Auxiliary Thrift Shop in Margaretville, New York.

Personal Waste Audit

Now it's time to analyze all the waste that you generate in a week.

Write down each item you generate throughout the week, and note whether it's recyclable or compostable. An easier way to do this for a household is to wait to take out the trash and recycling for one week, then hold a house meeting to look through it all. (I suggest using a clear bag for the trash that week, so that you can see everything.)

Think about reducing your overall waste and switching away from items that are non-recyclable. Make a list of things that you're good at now, what you plan to work on, and what improvements you want to work on in the future. Have realistic expectations and don't be hard on yourself. The items on your list should be completely personal to you.

Post your list on social media with this hashtag: #canirecyclethisaudit

How can you reduce your overall waste and switch away from single-use plastics and other items that are non-recyclable?

#canirecyclethisaudit

GOOD @ NOW
- USE REUSABLE SHOPPING BAGS
- COMPOST FOOD SCRAPS
- NO BOTTLED WATER
- NO FOAM FOODWARE
- VERY FEW TAKEOUT/DELIVERY MEALS!

WORKING ON NOW
- BUY LESS STUFF
- NO SINGLE-USE STRAWS
- BYO - CUP, STRAW, UTENSILS
- BUY THINGS IN PERSON (LESS SHIPPING)
- NO FROZEN PIZZA (BOXES ARENT RECYCLABLE)
- EAT stuff IN FRIDGE BEFORE it goES BAD

WORK ON NEXT
- REUSABLE PRODUCE BAGS
- FIND STORE w/ MILK IN REUSABLE BOTTLES
- LESS SPORTS DRINKS, MORE LEMONADE @ HOME
- LESS BOXED CEREAL (PLASTIC!)
- MORE HOMEMADE GRANOLA

WE'RE tHE "GOOD" PLAStic!

"BIODEgradABlE?" ↗

ARE tHEy TOO TINy TO MAKE iT THROUGH THE RECYCLING FACILITY?

Beware of Greenwashing

Greenwashing is when a product is marketed as better for the environment than the traditional version of a product. These products usually cost more, *but they actually aren't any better for the environment!* Companies often use greenwashing in their marketing to make consumers feel good by making them think less about where their products come from and how the products are disposed of. Unfortunately, greenwashing is incredibly effective: We've totally fallen for it.

You've already learned a lot about how the recycling system works, as well as composting, landfills, and plastics in the ocean. I've given you a framework for analysis, and now it's time to put that knowledge to use. When you see a marketing claim about recycling or biodegradability, try to imagine the logistics of how the claim would work. If you don't think that an item can be recycled, then avoid purchasing it if you can. Also, start conversations with your friends and on social media about recycling and greenwashing.

Notice any greenwashing in your day-to-day grocery shopping? Take a photo and post it on Twitter or Instagram with the hashtag #isthisgreenwashing, and tell the world why you think it's greenwashing.

Make Your Voice Heard to Corporations

You can also combat non-recyclable items and plastic pollution by making your voice heard to the corporations and manufacturers that produce the products you buy. Ask for bans on the worst types of packaging (plastic bags, foam foodware), greater recyclability of everything else, a shift toward reusable and refillable containers, and commitments to post-consumer recycled content in plastic products.

Successful examples of making your voice heard to corporations were the campaigns to get McDonald's to eliminate their use of PS #6 foam in their sandwich packaging. In the 1990s, young people and environmental groups organized and protested at their local McDonald's restaurants. McDonald's agreed to stop using foam in their sandwich packing at all U.S. restaurants. More recently, a shareholder advocacy group convinced McDonald's to halt PS foam in their packaging globally by the end of 2020.

Pressuring McDonald's led to changes in food packaging on a national basis for the biggest fast-food chain in the country. This happened at a time before there was the political will to take on foodware bans by legislatures on a large scale. Seeing that McDonald's could ditch foam foodware made the issue more palatable to some legislators, who began to vote for local and state bans on foam foodware.

Online petitions have led to some successes since corporations don't want bad publicity, but signing one can also sometimes give a false sense of completion. If you sign an online petition that demands a corporation make a specific change and you really care about the issue, go a step further and look into whether legislation is pending in your areas—and support that legislation!

Tell corporations that you value single-use plastic reduction and recycling.

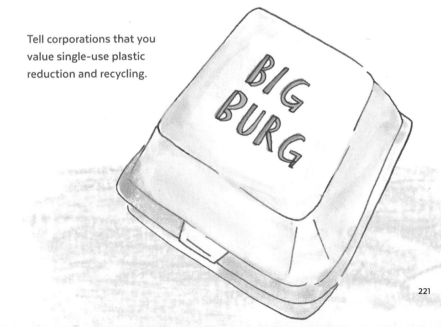

policy solutions

Introduction to Plastics Policy

Personal actions are important, but passing legislation will have a much bigger impact on the environment. That's why this section will give an overview of our legislative system and how to get involved, and provide specific examples of effective legislation.

My focus here is on effective plastic pollution reduction policy because that's what I have concentrated on for over a decade. These policies sometimes involve recycling, but more often they focus on source reduction and comprehensive legislation. I believe that policies ranging from local and federal laws to international agreements are needed to achieve the plastic reductions that we need, and to create a truly effective recycling system.

JENNIE THE AUTHOR

BREAK FREE FROM PLASTIC POLLUTION

How to Get Involved with Plastics Laws

One of the most effective ways to get involved with plastic pollution reduction laws is to become familiar with your elected officials at all levels of government, from your senator to your state and local officials. The focus here is on local officials, because your voice and vote often matter more in smaller constituencies, and local officials are often more likely to respond.

The first step is to figure out who your elected officials are. Your city's website probably features a search function where you can type in your address to find out which district you live in and who your local elected officials are. The website might also be kind enough to list your state and federal elected officials too. If not, you'll have to run a similar search on your state's website. Next, research your elected officials—who are they and what do they care about? Their official websites might provide a short biography and a list of policy goals. If not, a quick internet search should help. Do they seem to have any interest in recycling or plastics or environmental issues?

Next, write a letter to your elected official letting them know that you care about effective plastic reduction policy (not just recycling). If there are particular bills pending, you should focus on those; if not, just keep it general. Elected officials care about what their constituents want, and very few people write letters, so a written letter can go a long way.

Find Organizations Working on Plastics Policy

A great way to get involved in plastics policy is to find and plug into a local organization working on those issues. If there has been any interest in plastics in your community—perhaps a proposed plastic bag law—I suggest searching for local newspaper articles on the subject. If a local legislator has introduced legislation on the issue, newspaper articles will likely mention them, often along with any environmental groups that are calling attention to the issue. Contact the legislator mentioned in the articles, as they will probably have ideas on how you can get involved and which organizations to reach out to.

If you don't find any newspaper articles, try contacting your local elected official and tell them that you care about these issues. If your local elected official doesn't seem interested, find the most pro-environment legislator in your area. Reach out to them and see whether they care about plastic reduction and waste. If they do, ask for advice on how to get involved.

#breakfreefromplastic

You can also try contacting local environmental groups to see if they are working on plastics policy. Break Free From Plastic (BFFP) is the global movement that I have been very involved with. BFFP is a great resource for learning more about plastic pollution and organizations working to address it. You can likely find an organization working on plastics policy through the BFFP website. The Surfrider Foundation is a member—and personally, I think it's one of the best!

There is also tremendous value in having conversations with family, friends, and coworkers about plastic pollution and recycling. Let them know about the personal actions you are taking as well as the legislative actions that can be taken to reduce single-use plastic and to make recycling more effective.

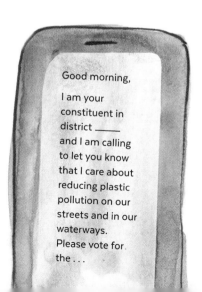

Good morning,

I am your constituent in district ____ and I am calling to let you know that I care about reducing plastic pollution on our streets and in our waterways. Please vote for the . . .

How a Bill Becomes a Law

A bill is drafted and introduced by a member of the legislature, then the legislative body has to adopt it. Once it's signed by the executive, it becomes a law.

(tHis HAppENs twiCE for BiCAmEkAL LEgislATHkES)

IDEA

BILL DRAFTED

FIRSt LEgislAtivE cHAmBER

committEE HEAking & votE

When a legislator has an idea for a law, they work with their staff to draft a bill. Legislators often rely on laws that have passed in other places, or they listen to ideas from constituents and interest groups.

The bill is introduced and assigned to at least one committee for a hearing, where testimony is heard from legislators, experts, and sometimes the general public.

The bill is then brought to a vote. If more than half of the full legislature votes yes, the bill passes. In most places, if more than two thirds of the members vote yes, that's a supermajority vote.

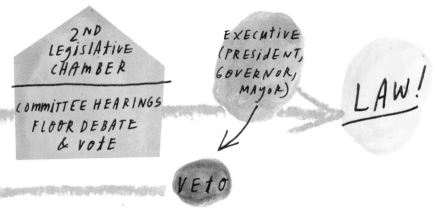

Most local legislative bodies (city council, board of supervisors) have only one chamber, but most state legislative bodies and Congress are bicameral—meaning that they have two houses, the Senate and the Assembly/House of Representatives.

In bicameral bodies, both houses need to adopt the bill before it's sent to the executive. When the bill gets to the executive, the executive may sign the bill or veto it. If a bill was passed by a supermajority in all chambers, that overrides a veto.

After the bill has been adopted by the legislature and signed by the executive, it becomes a law.

Examples of Plastics Laws

Below are examples of effective state and local plastics-reduction policies. These sometimes involve recycling, but more often they focus on source reduction.

PLASTIC BAG LAWS

The most effective bag laws are policies that address all carryout bag types, with either a fee on all bags, or a ban on thin plastic bags and a fee on all remaining bags.

FOAM FOODWARE BANS

The best policy is a ban on EPS foodware that's clear about which alternatives are allowable, including a ban on toxic PFAS chemicals in fiber-based foodware products.

STRAW LAWS

The best practice to address straws is a "straws upon request" policy rather than a ban, in order to address concerns from disabled community members. Plastic stirrers should be banned.

COMPREHENSIVE FOODWARE POLICIES

The foodware law in Berkeley, California, is a good example of a comprehensive foodware policy, which requires reusable foodware for all dine-in orders, makes utensils and condiments available only upon request for takeout and delivery, and mandates a twenty-five-cent charge for single-use cups.

BOTTLED WATER BANS

Most single-use water bottle bans apply only to bottled water sales at municipal buildings, the reasoning being that clean and safe drinking water is available in those buildings.

BEVERAGE-CONTAINER DEPOSITS

Beverage-container deposits are state-level laws that require customers to pay a deposit (usually five or ten cents) for a beverage container, which is refunded when the bottle is returned. This results in increased recycling rates and a cleaner stream of recycled containers.

RECYCLED-CONTENT MANDATES

Recycled-content mandates require that certain products be manufactured using a certain percentage of post-consumer recycled content; for example, 40% PCR in paper carryout bags and 50% PCR in beverage containers.

Extended Producer Responsibility (EPR) Laws for Packaging

I see producer responsibility laws for packaging—also called Extended Producer Responsibility (EPR) laws—as an ultimate goal for plastics and recycling policy. These laws go beyond simple bans and fees on certain products by holding product manufacturers accountable for the cost for recycling and waste disposal, as well as for cleanup, of their packaging. (Think of brands like Colgate-Palmolive or Danone, for example.) Right now that burden mostly falls on taxpayers and local governments, and sometimes volunteers. That's not only unfair, it leads to more wasteful and hard-to-recycle packaging because manufacturers don't consider the costs of managing waste when designing packaging for their products.

Producer responsibility policy isn't just wishful thinking. We have it in place for certain products in some U.S. states (tires and paint, for example)—and EPR for packaging is already happening in Europe and parts of Canada.

Producers must pay into a fund for the recycling/disposal and cleanup of the producer's packaging. The more wasteful their packaging, the more they must pay.

Packaging must meet certain criteria; other criteria are optional, but incentivized. Producers that meet the incentivized criteria pay slightly less into the fund.

REQUIRED	INCENTIVIZED
Recyclable or compostable	Even greater PCR%
Certain PCR%	Reduced packaging
Source reduction	Refillable/reusable
Ban certain toxics	Non-detachable lid

 Non-detachable lid

 No non-recyclable shrink sleeves

High PCR%

→ More sustainable packaging is produced

Product is sold and consumed

Customer recycles the packaging

Money from the fund manages (or reimburses local governments for managing) all of the above costs

→ This shifts the costs from local governments to producers.

By shifting the financial responsibility, EPR creates a structure where producers are incentivized to design products that are easier to recover and recycle—as well as reusable/refillable systems.

The Break Free From Plastic Pollution Act (BFFPPA)

The Break Free From Plastic Pollution Act (BFFPPA) is a monumental piece of federal legislation that was introduced in Congress in February 2020. The bill is a road map for how to address the plastic pollution problem in the U.S. and was developed by legislators in consultation with environmental groups and other experts. In fact, I'm proud to say that I introduced the two sponsors' offices—Senator Tom Udall (D-N.M.) and Representative Alan Lowenthal (D-Calif.)—and encouraged them to work together in crafting the legislation.

The legislation looks at virtually the entire life cycle of plastics, from its creation to manufacturing and disposal, and is named after the #breakfreefromplastic movement, which also takes a holistic approach.

Ban on plastic film carryout bags and a ten-cent fee on all other carryout bags

Ban on plastic utensils and certain non-recyclable items; straws upon request

Extended Producer Responsibility (EPR), which would shift the cost burden from taxpayers to product manufacturers, incentivizing them to make more sustainable packaging

Labeling requirements for products and receptacles

Pause on permits for new plastic facilities

Ten-cent deposit on all beverage containers in the U.S.

Requirements for post-consumer content in beverage bottles and other covered products

Ban on international export of plastic waste

The Future of Plastics Policy

Let's imagine that the Break Free From Plastic Pollution Act passes, alongside bills that incentivize the creation of reuse systems; where will we be in ten or fifteen years?

Imagine walking into a major grocery store and almost everything is available in bulk—even your favorite brands of cereal and shampoo! You pick up dinner on the way home, and it comes in a reusable container that you can return for a deposit. Everyone leaves their house with a reusable bag and a small kit of reusable cutlery and containers. Beverages are available in reusable glass bottles that are refilled locally, and sometimes in aluminum. Packaging is very minimal and highly recyclable because corporations are financially responsible for recycling and cleanup. Recycling is done domestically under a transparent process, and the reasoning behind that is that people understand the humanitarian impacts of exporting plastic waste, not just the environmental reasons. This stimulates growth in domestic manufacturing jobs. Less fossil fuel is being extracted, and plastic production has dropped dramatically. Air quality has improved and asthma has decreased. Streets and oceans are cleaner, sea turtles encounter fewer plastic bags and straws, and albatross feed in the open ocean on squid rather than on floating plastic debris.

Trevor Noah interviewed me about recycling for his podcast a couple of years ago, and one of the questions he asked me was "If you could wave a magic wand, how do we fix these things?" My answer was that we need to pass federal legislation (when the Break Free From Plastic Pollution Act was still under development). Trevor said that I did not understand the concept of magic wands. My revised wish was that everyone would start to carry around

everything reusable—and both of my answers still stand. Sometimes it feels like we need a magic wand to reach my vision for the future, but my hope is that we can get there through paradigm-shifting legislation along with a change in mind-set causing customers to think more about what they purchase. To make that happen, we need all hands on deck: Call your legislators, get involved, don't put up with the recycling system that we currently have. We can make it happen!

On a more personal note, I hope that this book inspires you to become involved with plastics reduction and recycling. Beyond that, I hope that my story inspires you to find an issue that you care about and organize around it.

Reuse or Recycle This Book!

The pages of this book are recyclable and made with 30% post-consumer recycled content. Since this book is hardcover, we suggest separating the cover from the pages if you want to recycle the pages. However, I strongly recommend reusing this book by sharing it with your family and friends, selling it to a local used bookstore, or donating it to your local library.

Let's keep in touch!

Visit canirecyclethisbook.com to follow our journey and learn more about how you can get involved. You can also follow the book on Instagram at @canirecyclethisbook and on Twitter at @cirtbook. Send us your questions, thoughts, photos of you reading the book, recycling, reducing, reusing, and getting active in your community and involved with policy!

You can also reach me personally on Instagram at @jenniethefreckle and on Twitter at @jennie_romer.

Don't forget to use the hashtags #canirecyclethis, #canirecyclethisaudit (page 216), and #isthisgreenwashing (page 219)!

Acknowledgments

This book is dedicated to my mentor and friend, Leslie Tamminen, education and programs director at 7th Generation Advisors. Leslie taught me how to build and run coalitions, encouraged me that being a plastic bag law expert could be a real job, and patiently tried to teach me to surf. When I moved from San Francisco to New York City to push for a plastic bag law with no job lined up and no savings, Leslie sent me a box of her warm winter coats. I don't know where I would be without all the dinner table conversations had when visiting Leslie and her husband, Terry Tamminen. They have both taught me so much.

I would like to acknowledge the following people who generously shared their knowledge and provided feedback: Susan Robinson and her team at Waste Management; Jonathan Black and Kate Voss at Senator Tom Udall's office; Shane Trimmer at Congressmember Alan Lowenthal's office; Kara Napolitano at Sims Municipal Recycling; Bridget Anderson at NYC Department of Sanitation; Shilpi Chhotray and Caro Gonzalez at Break Free From Plastic; Eadaoin Quinn at EFS-plastics Inc.; Lynn Hoffman and Miriam Holsinger at Eureka Recycling; Ron Gonen at Closed Loop Partners; Marcus Eriksen at The 5 Gyres Institute; Susan Collins at the Container Recycling Institute; Jane Patton at the Center for International Environmental Law; Christopher Chin at the Center for Oceanic Awareness, Research, and Education; Denise Patel at Global Alliance for Incinerator Alternatives (GAIA); Yifei Li at NYU Shanghai; Jack Macy at SF Environment in the City and County of San Francisco; Heather Trim at Zero Waste Washington; Mike Schade at Safer Chemicals, Healthy Families; Laura Rosenshine at Common Ground Compost; Bryan Staley at

Environmental Research & Education Foundation; and Andrew Radin at Onondaga County Resource Recovery Agency.

Thank you to the Surfrider Foundation's Plastic Pollution Initiative team for being great allies in the battle against plastic pollution, especially legal director Angela Howe. I would also like to specially acknowledge Christina Boulanger-Bosley at RecyclingMarkets.net for letting me print their historic pricing data.

I will forever be grateful to my editor, Matt Klise, and my agent, Lindsay Edgecombe. They trusted me and pushed me to make this book great. Another very special thank-you to Christie Young for making my vision come alive—and for making it stylish! Also, thank you to my editorial and research assistant, Lily Iserson. You are all joys to work with!

I would like to thank my friends and collaborators whom I met through plastic bag activism and lovingly call my "plastic bag friends": Lilly Bellanger (a.k.a. "my duckling"), Korin Tangtrakul, Dorothee Pierrard, Marianne Schwab, Joe Harvell, Erika Jozwiak, Logan Welde, Emily Utter, and my environmental happy hour crew. To all of the members of the various plastics coalitions that I've been part of over the years—I've learned so much on our endless conference calls. Thank you to NYC Council Members Brad Lander and Margaret Chin for allowing me to be your pro bono counsel on the NYC bag bill; we made a great team. Thank you also to my inspiring activist friends with their own issue areas: Rita Pasarell, Lisa Bloodgood, Emily Gallagher, Brandon West, Jenna Bimbi, leaders and alumni of North Brooklyn Neighbors (formerly known as NAG) and members of the New Kings Democrats political club in Brooklyn.

I owe a special debt to my brilliant and inspiring husband, Cisco Bradley, for being patient with me as I spent countless nights and weekends writing this book. I am also thankful to my creative

and confident stepdaughter, Juliette Eloise "Danger" Athens Bradley, for being an excellent sidekick. Thank you to my mom, Pat Harbo, for taking me to the El Cerrito recycling center, being a good mom, inspiring me with her writing, and supporting my rather individualistic pursuits. Thank you to my dad, Walter Romer, for remaining positive and continuing to crash parties. Thank you to my brother, Lucas Romer, for always being there for advice, vibe consulting, and hard chilling. Thank you to my aunt and uncle, Lorraine and Bill Thomas, for paying for my college applications and always having their guest room available for a last-minute visit—and Kathy, for driving me to look at colleges. Thank you to Mary Pettis-Sarley and Chris Sarley, for letting horses be horses. Thank you to the faculty and staff of the Environmental Studies program at University of California at Santa Barbara and the Environmental Law program at Golden Gate University School of Law for providing me with an excellent background in environmental policy. Thank you to Cailin Ettenger for always knowing exactly where things need to be. Thank you to Anne Blaschke for asking whether you could recycle your clementines bag. Thank you to Kristin Henry at the Sierra Club, for coaching me in the appellate advocacy competition—with your help, my public speaking prowess went from super wonky to decidedly less wonky. Lastly, thank you to Ken Sarachan for putting me in charge and for teaching me that all I need is a phone book to create a mosaic floor.

Sources

Below we have gathered sources for further reading that relate to certain sections of the book.

Resin Identification Codes Greenpeace, "Circular Claims Fall Flat: Comprehensive U.S. Survey of Plastics Recyclability," February 18, 2020, greenpeace.org/usa/wp-content/uploads/2020/02/Greenpeace-Report -Circular-Claims-Fall-Flat.pdf, at p. 10.

History of Resin Identification Codes NPR, "How Big Oil Misled The Public Into Believing Plastic Would Be Recycled," *Morning Edition*, September 11, 2020, npr.org/2020/09/11/897692090/how-big-oil-misled-the-public -into-believing-plastic-would-be-recycled; *Frontline*, season 2020, episode 14, "Plastic Wars," produced by PBS, in partnership with NPR and IRW: American University School of Communication, pbs.org/wgbh/frontline /film/plastic-wars, aired on March 31, 2020, at 19:51.

Material Types Made with Plastic Resins ISRI: Institute of Scrap Recycling Industries, Inc., "ISRI Scrap Specifications Circular effective 03/2020," sponsored by ISRI and Steinert, isri.org/recycling-commodities/scrap -specifications-circular, at p. 36.

Fenceline Communities NAACP and Clean Air Task Force, "Fumes across the Fence-Line: The Health Impacts of Air Pollution from Oil & Gas Facilities on African American Communities," November 2017, catf.us /resources/publications/files/fumesacrossthefenceline.pdf, at pp. 6, 14.

Total Waste Generation Geyer, Roland, Jenna R. Jambeck, and Kara Lavender Law, "Production, Use, and Fate of All Plastics Ever Made," *Science Advances* 3, no. 7, e1700782, advances.sciencemag.org/content /3/7/e1700782, published on July 19, 2017; and U.S. Environmental Protection Agency, "Total MSW Generated (by material), 2017," epa.gov /sites/production/files/2019-11/documents/2017_facts_and_figures _fact_sheet_final.pdf, at p. 7.

Global Plastic Production Ellen MacArthur Foundation, "The New Plastics Economy: Rethinking the Future of Plastics & Catalysing Action," January 19, 2016, ellenmacarthurfoundation.org/assets/downloads /EllenMacArthurFoundation_TheNewPlasticsEconomy_Pages.pdf, at p. 24.

What We Recycle and **How We Recycle** Recycling Partnership, The, "2020 State of Curbside Recycling Report," February 13, 2020, recyclingpartnership .org/stateofcurbside/ at p. 10.

Commodities Pricing: It's All About End Markets! Historical commodities pricing data printed with special permission from RecyclingMarkets.net. Tipping fees information is courtesy of the Environmental Research & Education Foundation, analysis of 2016 to 2019 data, erefdn.org/product /analysis-msw-landfill-tipping-fees-2/.

Incineration Tishman Environment and Design Center at The New School, "U.S. MSW Incinerators: An Industry in Decline," May 2019, no-burn.org /industryindecline/, at p. 4.

Chemical Recycling Patel, D., Moon, D., Tangri, N., Wilson, M. "All Talk and No Recycling: An Investigation of the U.S. 'Chemical Recycling' Industry by Global Alliance for Incinerator Alternatives," July 2020, doi.org/10.46556/WMSM7198.

Plastic Water Bottles and Caps U.S. Environmental Protection Agency: Office of Resource Conservation and Recovery, "Documentation for the Waste Reduction Model (WARM)," February 2016, epa.gov/sites/production /files/2016-03/documents/warm_v14_containers_packaging_non-durable _goods_materials.pdf, at p. 55.

Aluminum Soda Cans Aluminum Association, The, "The Aluminum Can Advantage: Key Sustainability Performance Indicators, September 2019," aluminum.org/sites/default/files/KPI%20Report%202019.pdf, chart on p. 2.

Glass Beer Bottles Moore Recycling Associates Inc. and Resource Recycling Systems, "2015–16 Centralized Study on Availability of Plastic Recycling," greenblueorg.s3.amazonaws.com/smm/wp-content/uploads /2017/06/SPCs-Centralized-Availability-of-Recycling-Study-3.pdf, at p. 9.

China's National Sword Policy Staub, Colin, "China: Plastic Imports Down 99 Percent, Paper Down a Third," *Resource Recycling*, January 29, 2019, resource-recycling.com/recycling/2019/01/29/china-plastic-imports -down-99-percent-paper-down-a-third.

Ban International Export of Plastic Waste United Nations Environment Programme, "Basel Convention Plastic Waste Amendments," 2019, basel .int/Implementation/Plasticwaste/PlasticWasteAmendments/Overview /tabid/8426/Default.aspx. Wang, Jiu-liang, dir., *Plastic China*, produced by Ruby Chen with the CNEX Foundation, released November 16, 2016, amazon.com/Plastic-China-Jiu-liang-Wang/dp/B06XTLG4Q4.

Turtles and Albatross Kühn, S. and Van Franeker, J. A., "Quantitative overview of marine debris ingested by marine megafauna," Marine Pollution Bulletin 151, 2020, p.110858; Wilcox, Chris, Erik Van Sebille, and Britta Denise Hardesty, "Threat of Plastic Pollution to Seabirds Is Global, Pervasive, and Increasing," *Proceedings of the National Academy of Science of the United States of America,* published August 31, 2020, doi.org/10.1073/pnas.1502108112.

Plastic On Our Plates Baechler, Britta R., Elise F. Granek, Matthew V. Hunter, Kathleen E. Conn, "Microplastic concentrations in two Oregon bivalve species: Spatial, temporal, and species variability," November 12, 2019, doi.org/10.1002/lol2.10124.

Break Free From Plastic Pollution Act (BFFPPA) Break Free From Plastic Pollution Act of 2020, S.3263, 116th Cong., congress.gov/bill/116th-congress/senate-bill/3263, from 2019–20.

Highly recommended documentaries and movies to learn more about recycling, how to reduce single-use plastics, and toxic chemicals:

Story of Plastic

Plastic Wars

Plastic China

Dark Waters

Index